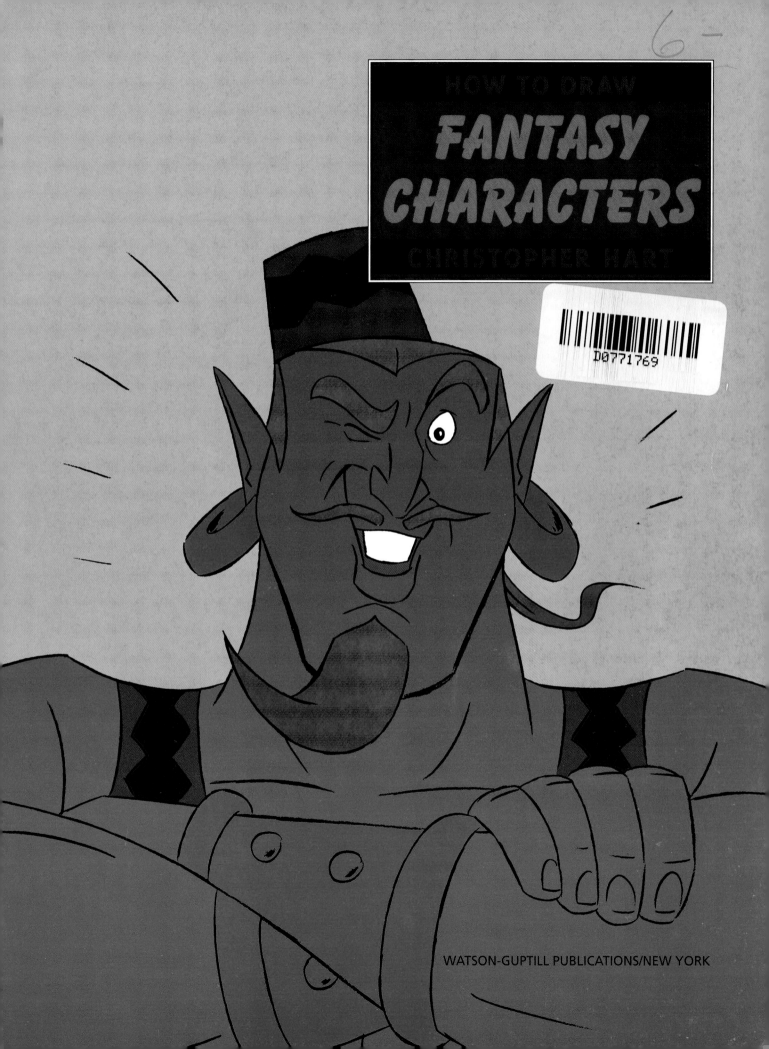

WATSON-GUPTILL PUBLICATIONS/NEW YORK

For Isabella

Senior Editor: Candace Raney
Project Editor: Alisa Palazzo
Designer: Bob Fillie, Graphiti Design, Inc.
Production Manager: Ellen Greene

Cover art by Christopher Hart
Text and illustrations copyright © 1999 Christopher Hart

First published in 1999 by Watson-Guptill Publications,
a division of BPI Communications, Inc.,
1515 Broadway, New York, N.Y. 10036

Library of Congress Cataloging-in-Publication Data
Hart, Christopher.
 How to draw fantasy characters / Christopher Hart.
 p. cm.
 Includes index.
 Summary: Instructions for drawing fantasy characters, including mythological
heroes, elves, fairy godmothers, and unicorns.
 ISBN 0-8230-2376-1 (pbk.)
 1. Art and mythology—Juvenile literature. 2. Animals, Mythical, in art—Juvenile
literature. 3. Drawing—Technique—Juvenile literature. [1. Art and mythology.
2. Animals, Mythical, in art. 3. Drawing—Technique.] I. Title.
NC825.M9H37 1999
743'.87—dc21 98-40656
 CIP
 AC

Printed in Singapore

First printing, 1999

1 2 3 4 5 6 7 8 / 06 05 04 03 02 01 00 99

CONTENTS

Introduction 5

Sea Creatures 6

MERMAID MERMAN WALKING HIS MERDOG

THE MERMAID BODY SEA SERPENT

MERMAID POSES

Unicorns 14

THE HEAD THE UNICORN BODY

FRONT VIEW THE YOUNG UNICORN

3/4 VIEW YOUNG UNICORN EXPRESSIONS

Mythological Figures 22

ZEUS PAN COURTING A MAIDEN

ZEUS ENTHRONED PEGASUS

NEPTUNE THE CENTAUR

THE CYCLOPS THE FEMALE CENTAUR

THE CYCLOPS BODY CUPID

HERCULES CUPID EXPRESSIONS

PAN

Genies, Angels, and Fairies 44

MALE GENIE FAIRY GODMOTHER

FEMALE GENIE THE TOOTH FAIRY

GUARDIAN ANGEL FAIRY PRINCESS

Little Folk 56

ELVES THE GNOME BODY

THE ELF HABITAT LEPRECHAUNS

GNOMES "LITTLE PEOPLE"

Index 64

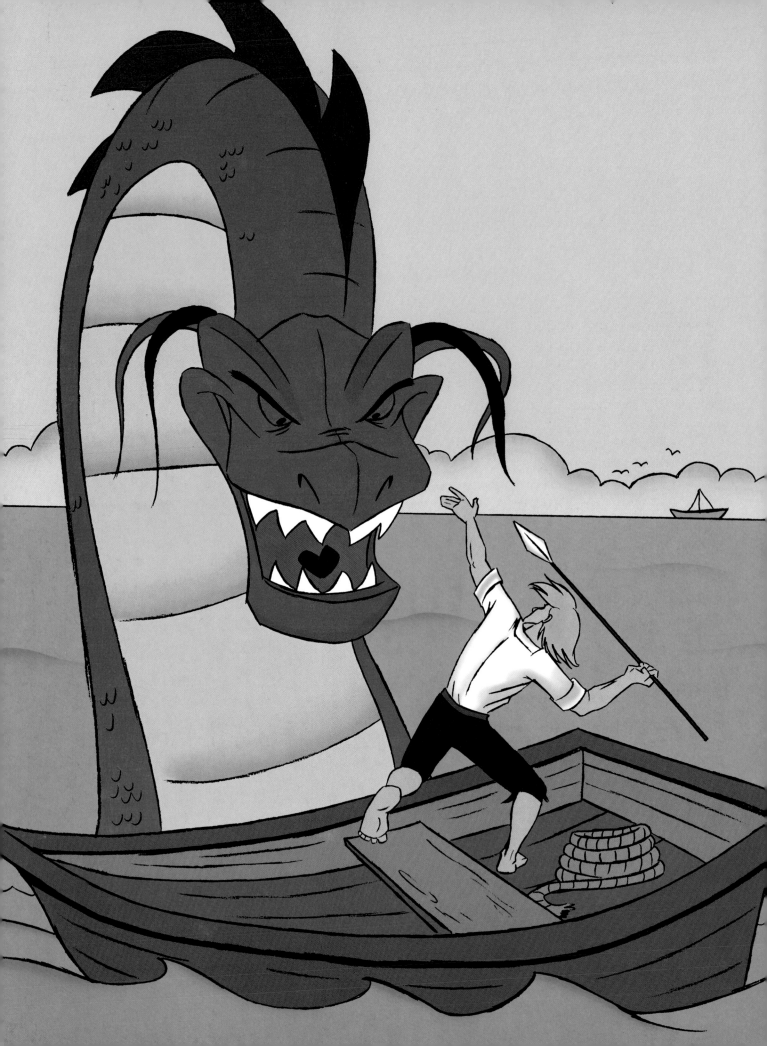

INTRODUCTION

Fantasy drawings hold a special fascination for people of all ages. The mystery and magic of fantasy illustration is unparalleled in its ability to captivate readers. It is popular in many forms, including animated feature films, comic books, comic strips, and of course, children's book illustrations.

In this book, you'll discover many of your all-time favorite fantasy characters, accompanied by easy to follow, step-by-step instructions that will show you how to draw them all. I have demonstrated several approaches to each of the more popular characters. As you continue in your artistic development, you'll discover your own, unique style, which may vary considerably from mine. That's as it should be, for as artists, we are each charting our own individual paths of discovery.

No matter what your drawing style, try to keep the following helpful guidelines in mind as you begin. Sketch loosely and roughly at first. Relax your hand, and don't press down either too hard or too timidly on your pencil. Strive for long, bold lines, rather than short, choppy ones. Don't draw too small; give yourself and your drawings the luxury of space. Your images are important—let them fill the page. And, don't hesitate to use your eraser liberally. In addition, color is an important element in fantasy illustration. You can use the colors you see in this book, or choose your own color schemes. In fantasy art, colors lean more heavily toward purples, blues, lavenders, pinks, and greens.

This book also strives to not only show you how to draw, but how to infuse your drawings with feeling and character—to bring out the lyrical qualities that are so important in good fantasy illustration. Of course, technique is very important; without it you cannot create convincing scenes. But your imagination—your feeling about what you're drawing—is even more key.

People often ask me if I first have the idea in my head of what I want to draw, or whether I simply draw and wait until the idea comes to me. Usually, it starts with only a feeling—an emotion, charged and pure, but without form. I use paper and pencil as the tools to seek out the source of that emotion. And when that source begins to reveal itself on the page, I pour all of my concentration into it, chipping away at it, refining it, trying to recreate that initial feeling on the paper. When I look at my final drawing, I pause to see whether it conveys that initial feeling I had when I started. If it doesn't, I redraw it until it does.

In this way, we artists have a very real relationship with our creations—a give and take. But it all starts with a feeling. Fantasy illustration conjures up worlds of wonder and emotion. So relax and enjoy yourself. Your pencil is your ticket on this voyage. Ready to set sail?

SEA CREATURES

Fantasy characters inhabit worlds of wonder. Mermaids live in kingdoms of the deep. Unicorns dwell in magical valleys. Angels survey the world from their homes in the clouds. Therefore, when drawing fantasy characters, like the sea creatures here, choose their settings accordingly.

Mermaid

Beautiful and alluring, mermaids hold a special fascination for us. In days of yore, sailors would return from their voyages at sea with tales of sightings of strange creatures that were half fish and half woman. Of course, these were only the mirages of men too long at sea. Or was it more than that?

When drawing the mermaid's head, keep in mind that she is under water; therefore, her gaze is dreamy and her hair flows gently, caressed by the ocean currents.

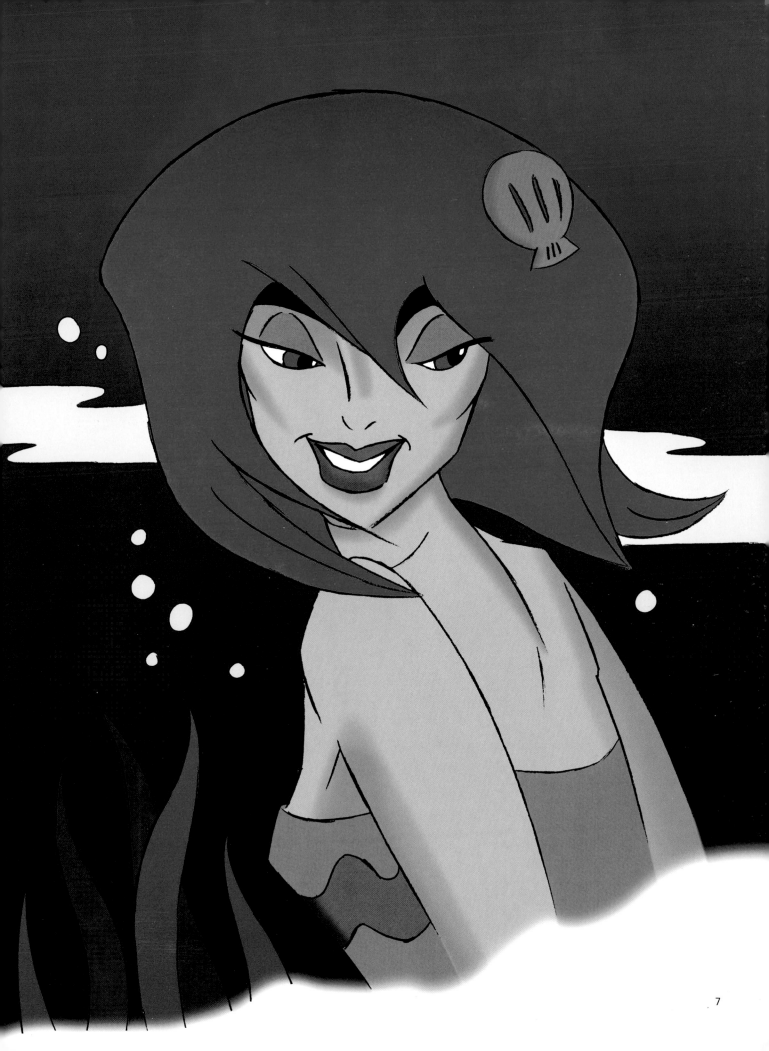

The Mermaid Body

The mermaid twists and turns as she glides effortlessly through the water. Along with the upper body of a woman and the tail of a fish, she has a sizeable tail fin that flaps up and down as it pushes against the water. In this underwater pose, the body should get bigger as the mermaid swims toward you; this is due to the principles of perspective, which state that forms that are closer to you will appear larger than those that are farther away.

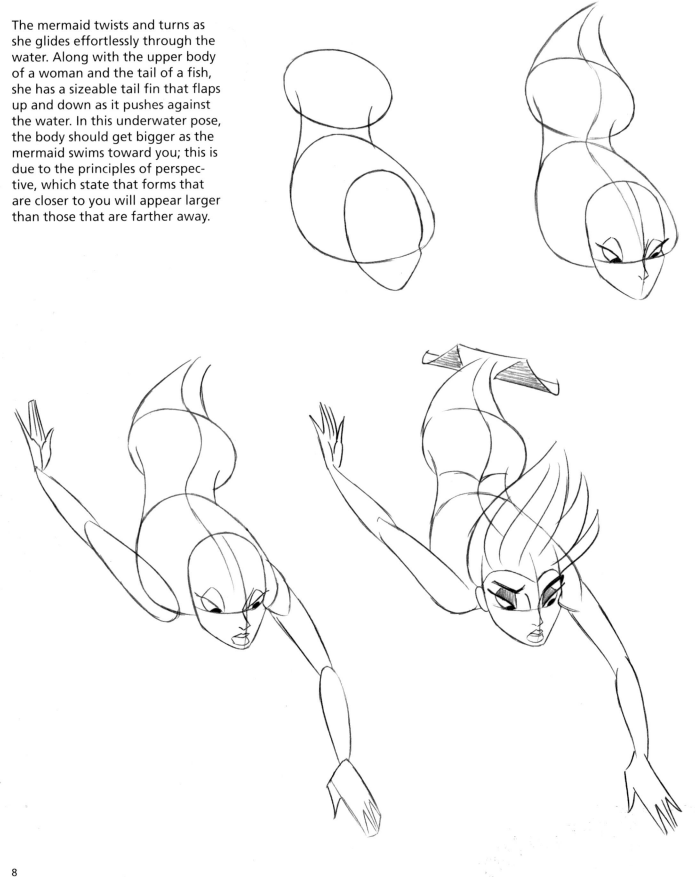

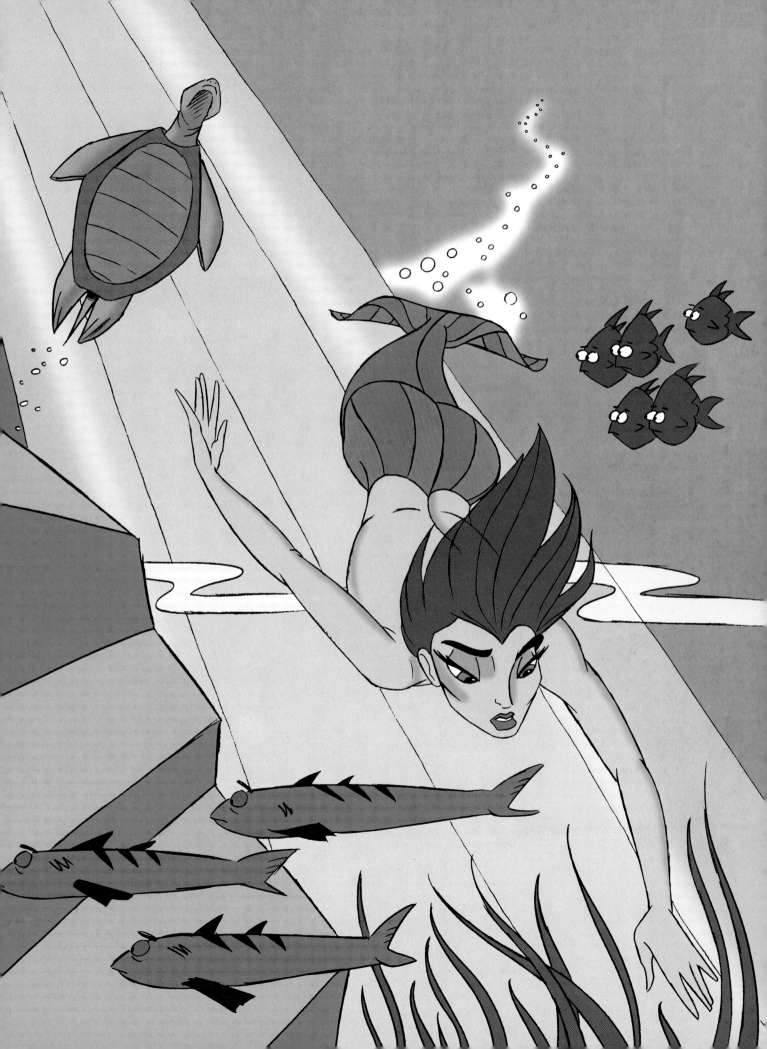

Mermaid Poses

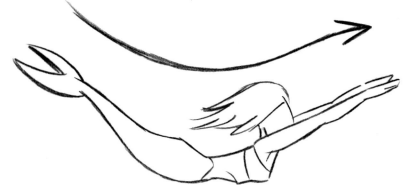

Go for one overall direction, or thrust, when planning a pose. It will make the pose that much stronger.

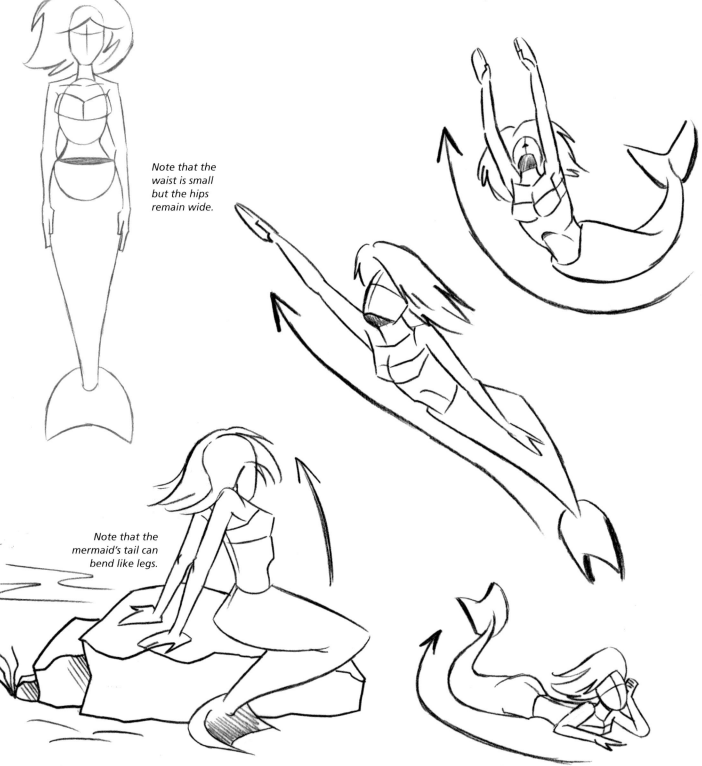

Note that the waist is small but the hips remain wide.

Note that the mermaid's tail can bend like legs.

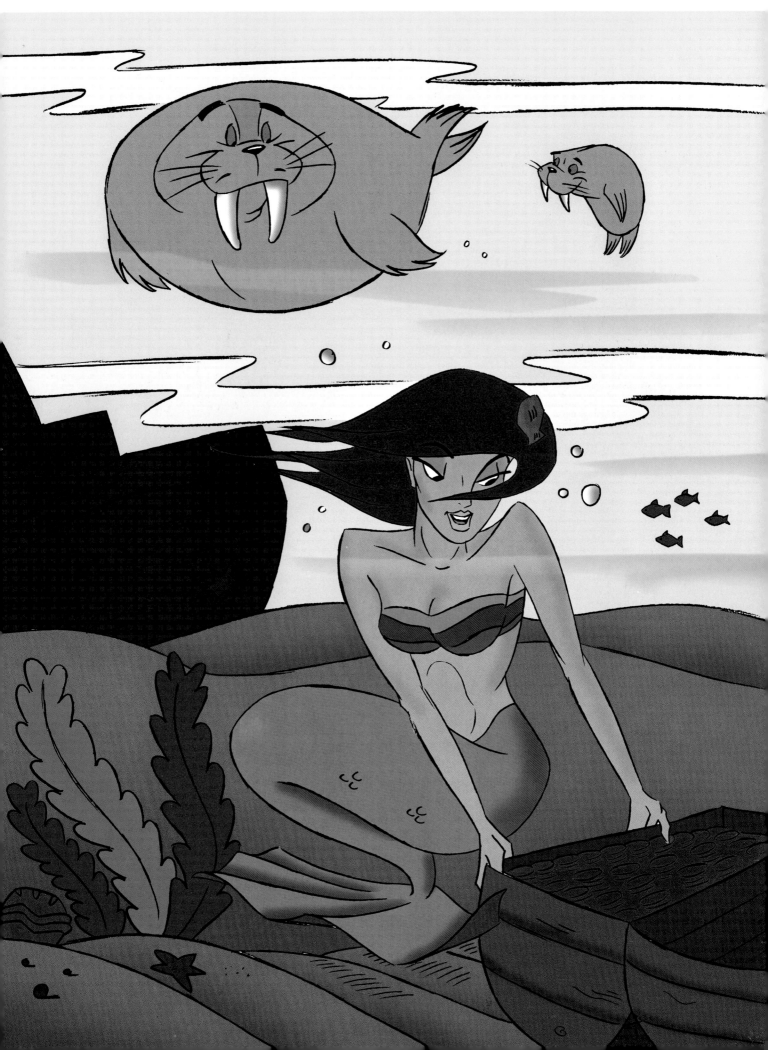

Merman Walking His Merdog

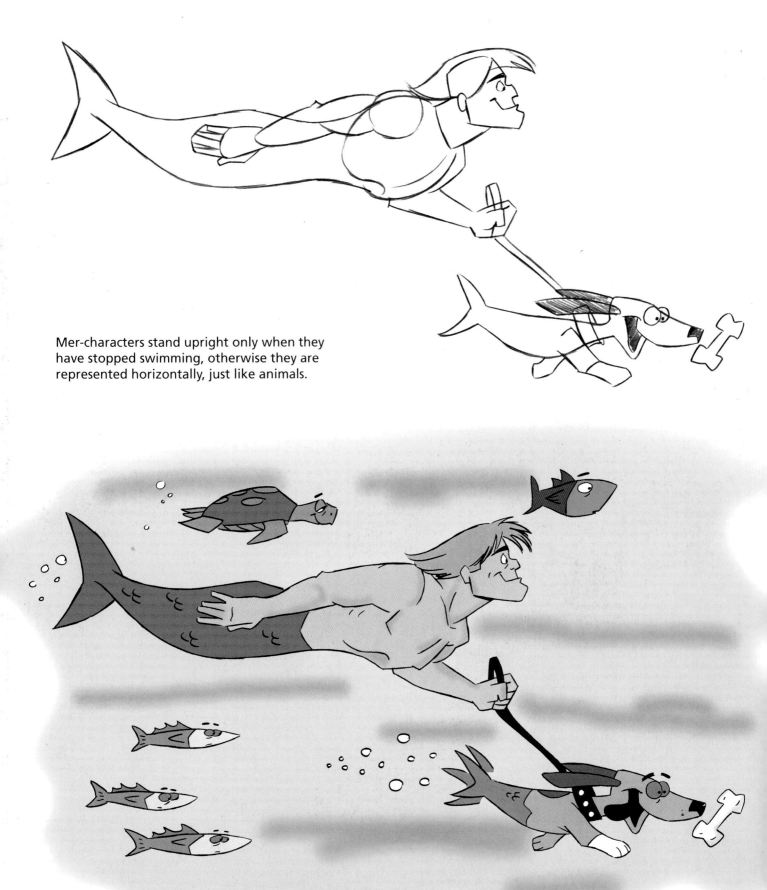

Mer-characters stand upright only when they have stopped swimming, otherwise they are represented horizontally, just like animals.

Sea Serpent

Here's a general rule of thumb: Don't pet the sea serpent. You can draw sea serpents many different ways. One method is to draw them as dragons with eel-like bodies (see page 4). Another method (shown here) borrows from "Tessy," the Loch Ness monster, who has an eel-like neck and a walrus-shaped body. Add strangely shaped dorsal fins and tail for a weird look.

UNICORNS

Unicorns have graced not only the pages of countless storybooks, but also ancient manuscripts, stained glass windows, and paintings throughout the ages. Their enduring popularity is ensured. But what is a unicorn? Is it simply a horse with a magical horn? Yes, it is that, but it is also much more. It is the embodiment of myth itself, and as such, must be drawn with a mystical quality, sweeping lines, graceful curves, flowing mane, glistening eyes, and compelling stature.

The Head

The head of a unicorn is based on an idealized horse head. It must be strong, yet graceful and beautiful to behold. Since the unicorn head is a bit easier to draw from the side, we'll begin with the profile.

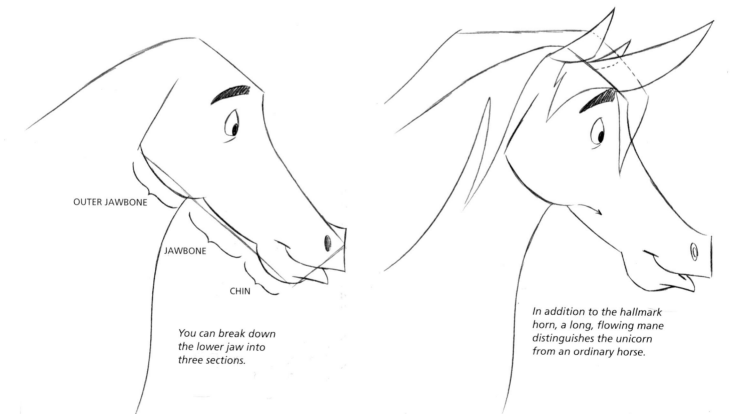

OUTER JAWBONE

JAWBONE

CHIN

You can break down the lower jaw into three sections.

In addition to the hallmark horn, a long, flowing mane distinguishes the unicorn from an ordinary horse.

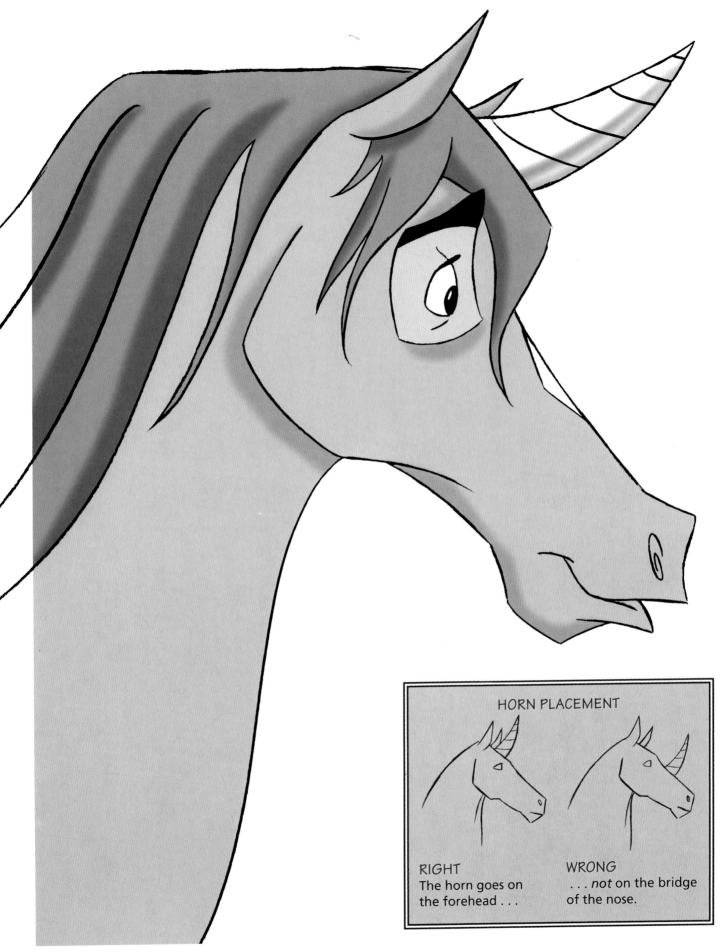

HORN PLACEMENT

RIGHT
The horn goes on
the forehead . . .

WRONG
. . . *not* on the bridge
of the nose.

15

Front View

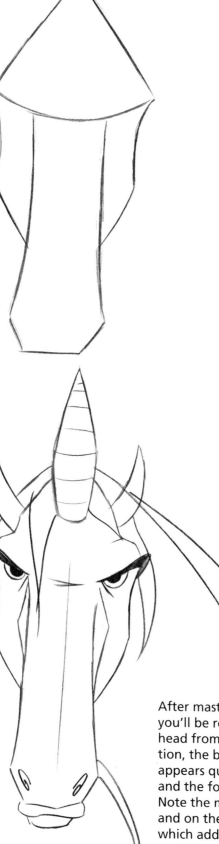

After mastering the side view, you'll be ready to draw a unicorn head from the front. In this position, the bridge of the nose appears quite long and narrow, and the forehead rises to a point. Note the markings—under one eye and on the bridge of the nose—which add character to the face.

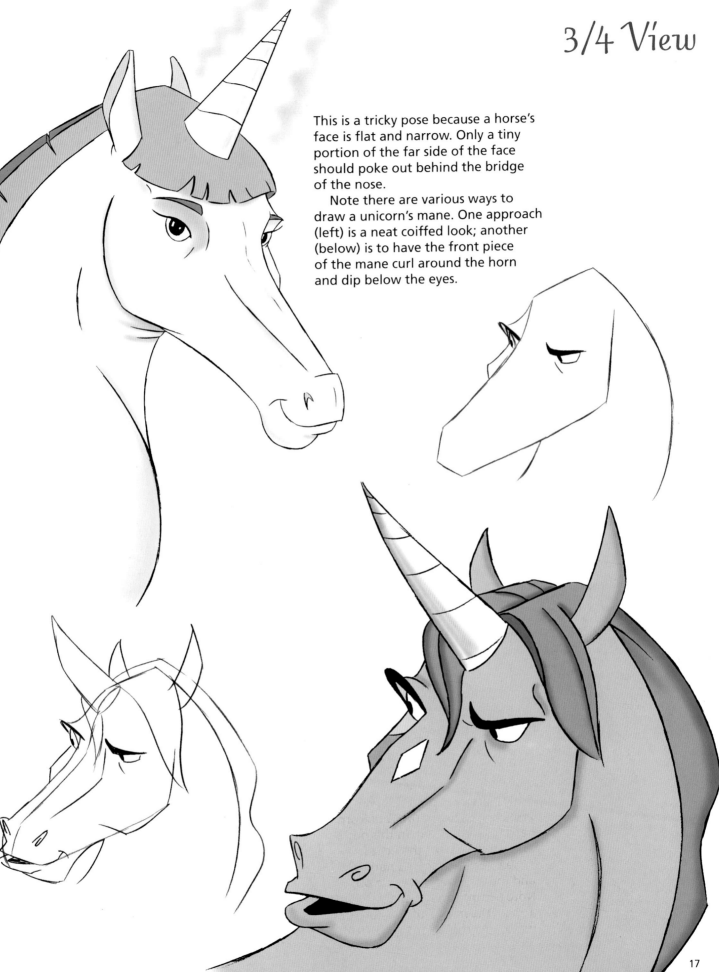

This is a tricky pose because a horse's face is flat and narrow. Only a tiny portion of the far side of the face should poke out behind the bridge of the nose.

Note there are various ways to draw a unicorn's mane. One approach (left) is a neat coiffed look; another (below) is to have the front piece of the mane curl around the horn and dip below the eyes.

The Unicorn Body

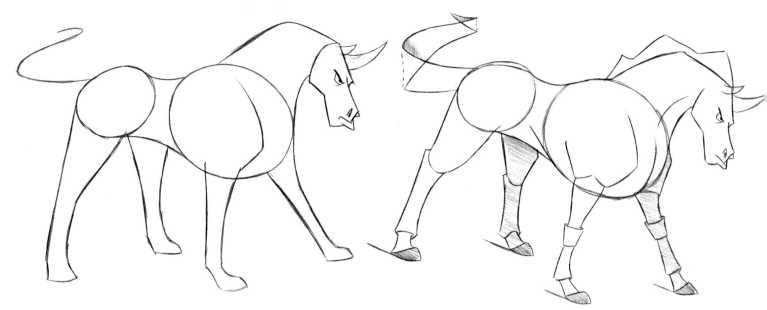

MALE
Note the sturdy legs and forceful stance of the male unicorn. Legend has it that unicorns were fearless fighters, prized for their horns—which were thought to have magical healing properties. Some books portray unicorns as serene and peaceful animals, but I prefer the original legend—that of the powerful, noble beast.

FEMALE

The female unicorn is more feminine in appearance than her male counterpart. Her forelegs and hind legs taper to smaller hooves, and her mane and tail are more elaborate. Also note the eyelids and eyelashes. However, she is still strong, athletic, and courageous.

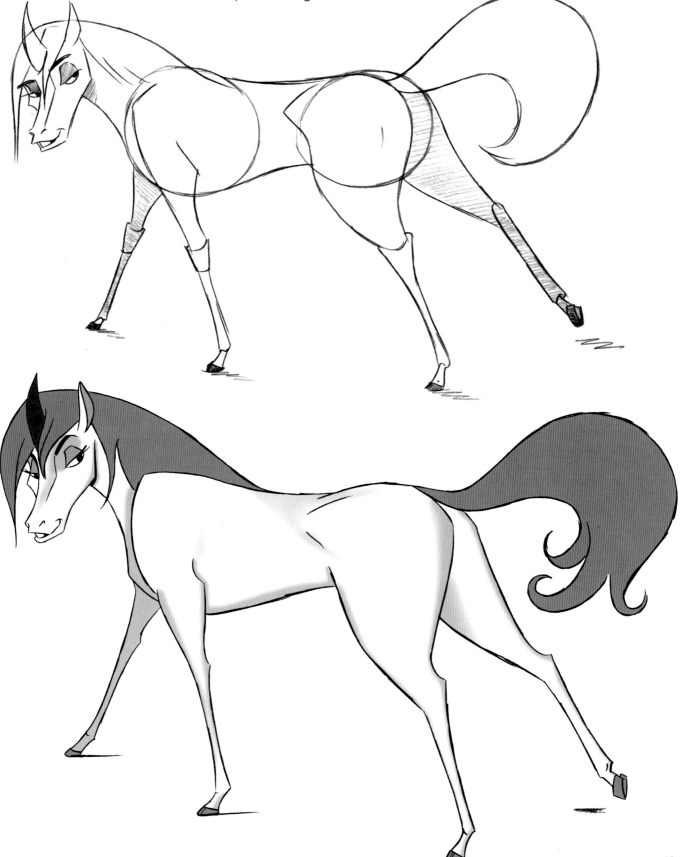

The Young Unicorn

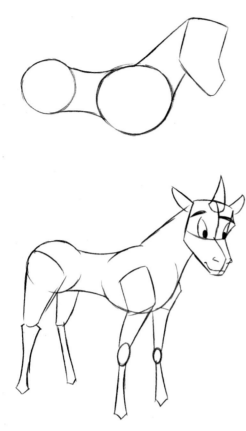

ADD THE CHEEK
ON THE FAR SIDE
IN THE 3/4 VIEW

Any youth is a bit gangly and awkward, and the young unicorn is no exception. The legs are on the long side, making the young unicorn less surefooted than its adult counterpart. The mane has not yet found a natural part. The eyes are big, as are the ears; but the nose and tail are small.

Young Unicorn Expressions

As a general rule, the younger the character, the more expressive the face can be. Younger characters have rounder, less angular faces, which you can stretch and squash to convey many emotional states. And, the big eyes always grab the reader's attention.

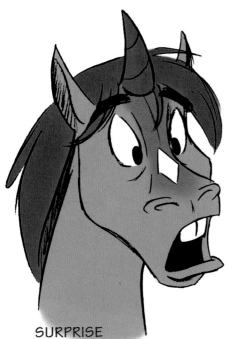

SURPRISE

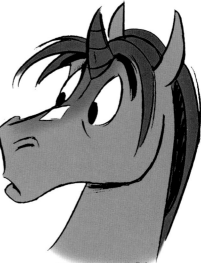

UNCERTAINTY

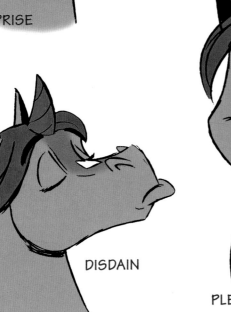

DISDAIN

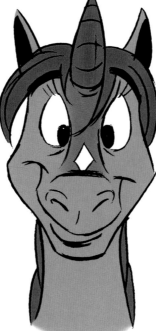

PLEASING THOUGHT

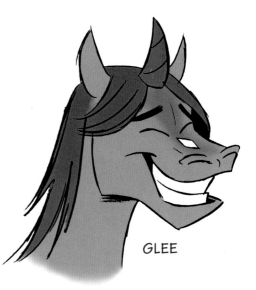

GLEE

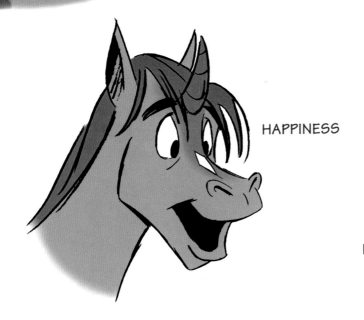

HAPPINESS

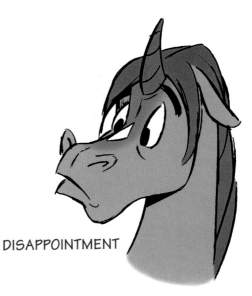

DISAPPOINTMENT

MYTHOLOGICAL FIGURES

Stories from Greek and Roman mythology provide a wealth of colorful characters. Many are gods and demigods; others are strange creatures. But all have fantastic powers that place them above the realm of mere mortals.

Zeus

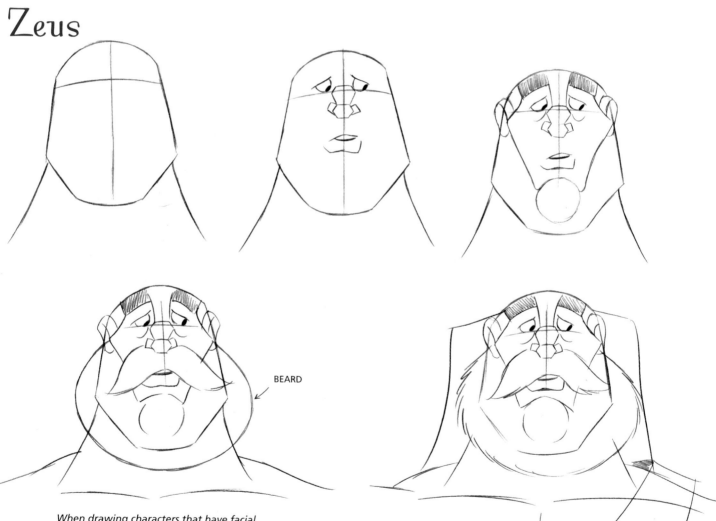

BEARD

When drawing characters that have facial hair, draw the basic construction of the face before adding the beard and/or mustache.

Awesome. Mighty. Commanding.
These are the words that come to
mind when thinking of Zeus, king
of the Greek gods. Although
he could be intimidating, Zeus
should also have moments of
quiet reflection—the Greek gods
were portrayed as feeling,
emotional figures.

Zeus Enthroned

According to Greek mythology, Zeus' throne is on Mount Olympus, home of the Greek gods. From this vantage point high among the clouds, Zeus can see everything that happens on Earth; he is master of all he surveys, and when upset, he can be quick to anger. Note that even though he is middle-aged, his physique remains strong and powerful.

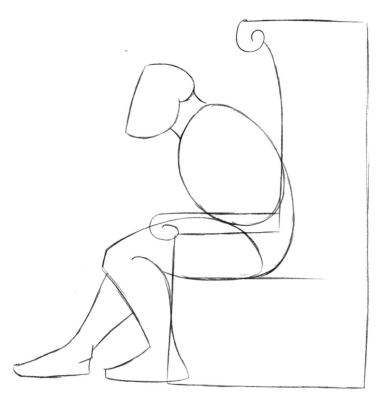

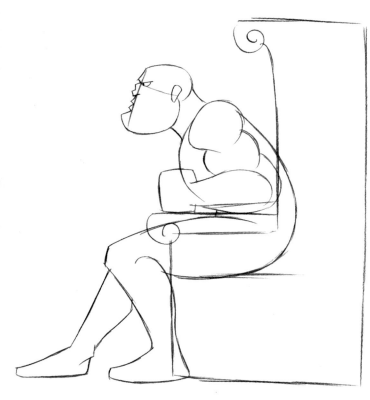

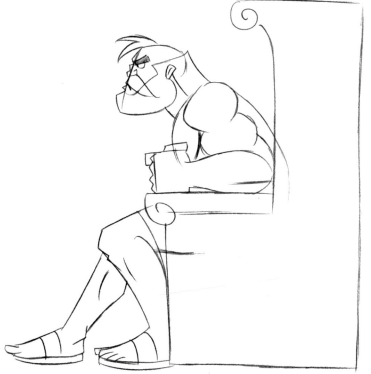

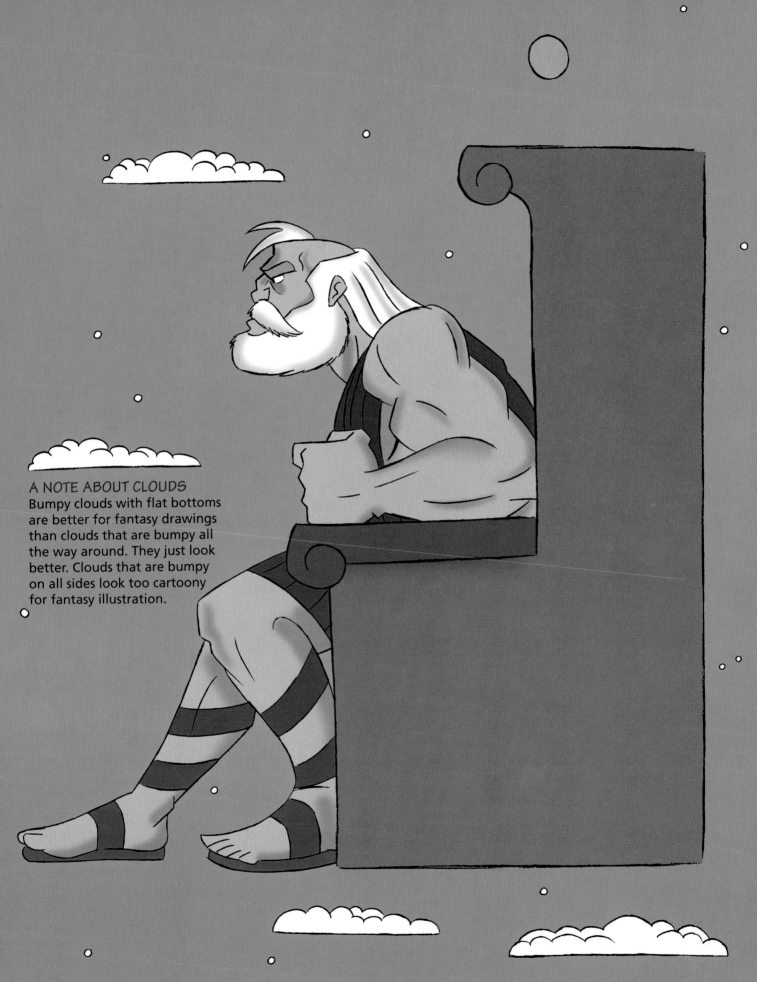

A NOTE ABOUT CLOUDS
Bumpy clouds with flat bottoms are better for fantasy drawings than clouds that are bumpy all the way around. They just look better. Clouds that are bumpy on all sides look too cartoony for fantasy illustration.

Neptune

Roman god of the sea, Neptune
must be of formidable stature,
bearded, and wise. He is usually
shown carrying his trident and
wearing a crown.

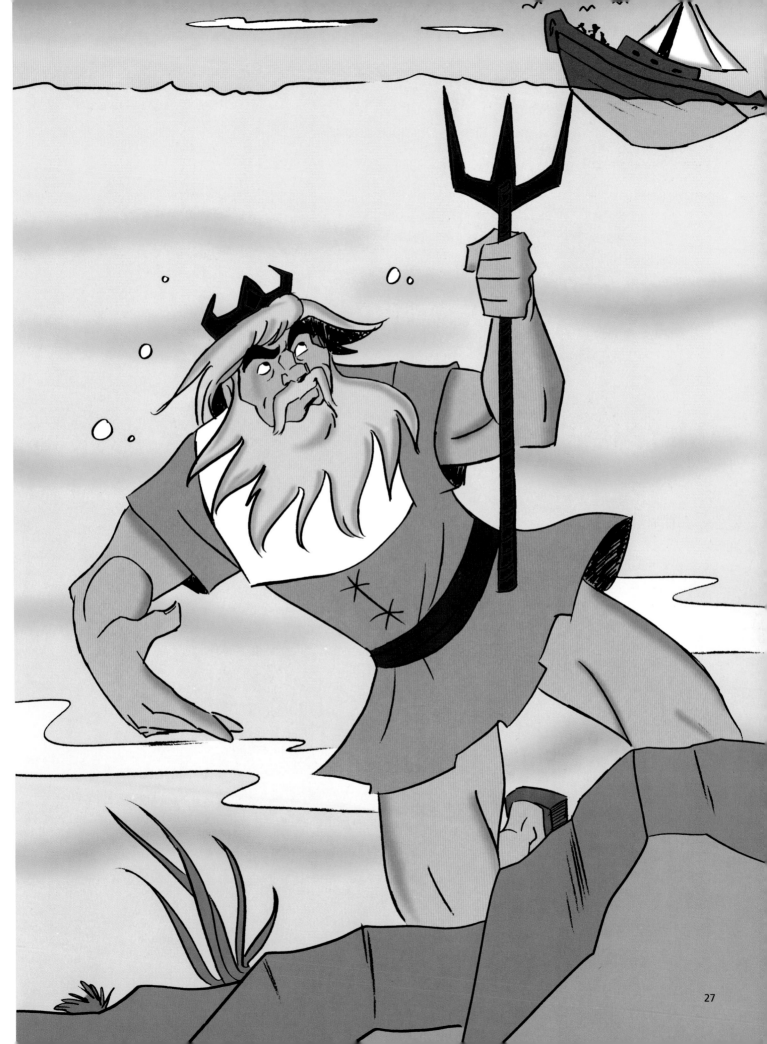

The Cyclops

Not all shapes need to be complex to have impact. The cyclops' head is based on a simple shape—the oval—but it looks awesome.

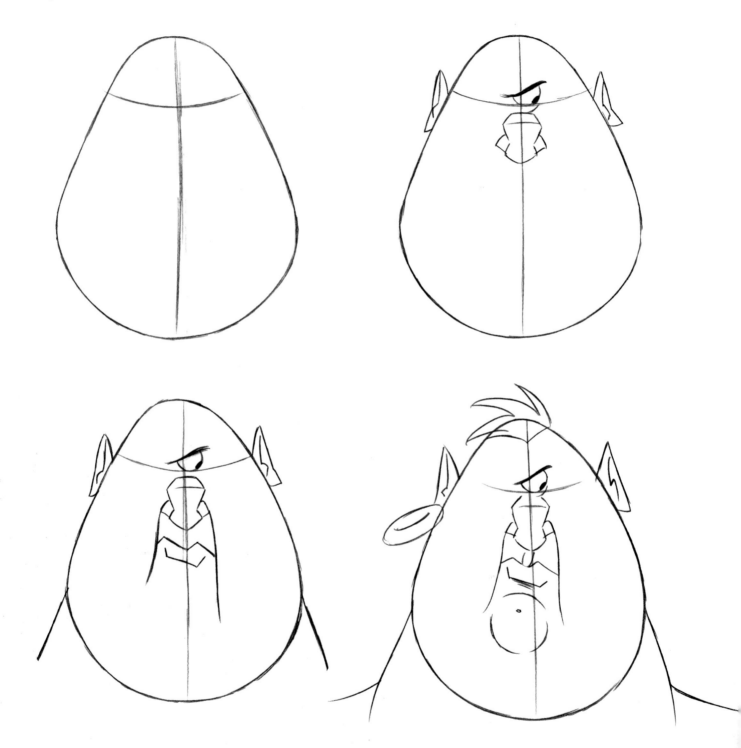

A cyclops is an evil, brutish creature whose single eye gives him an otherworldly appearance. He's also a giant, which is indicated here by his massive jaw and neck. I've given him pointed ears to underscore his evil nature.

The Cyclops Body

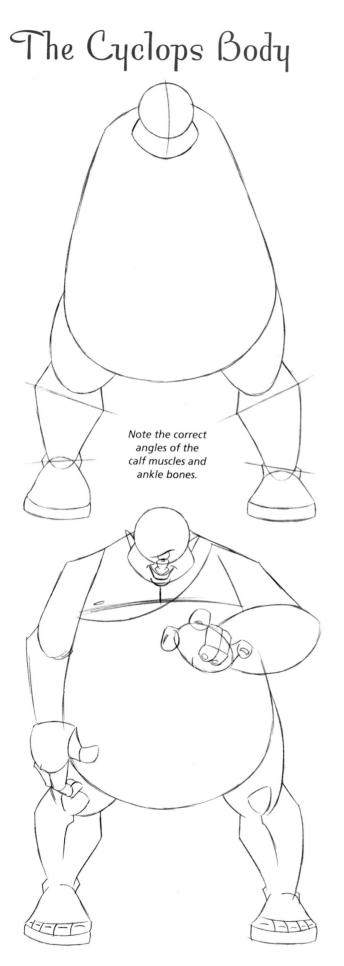

Note the correct angles of the calf muscles and ankle bones.

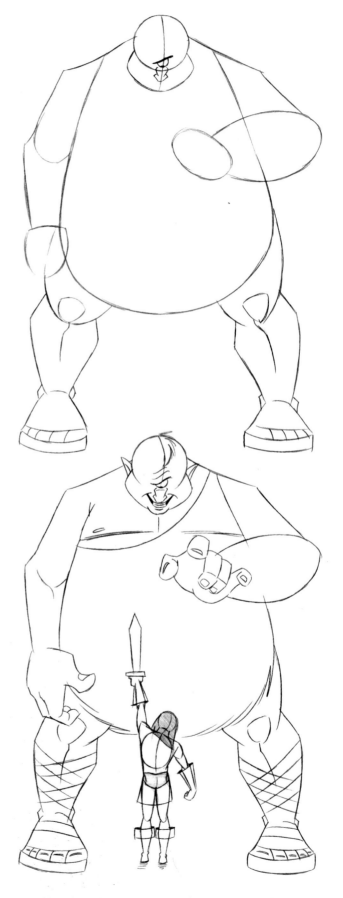

The body of a cyclops gets smaller toward the head and shoulders; this is due to perspective: the farther away something is, the smaller it appears. The head dips below the shoulders to give him a brutish look. Note the heroic, unflinching stance of the small warrior. This is true courage—a solitary figure facing a powerful enemy, against over-whelming odds.

Hercules

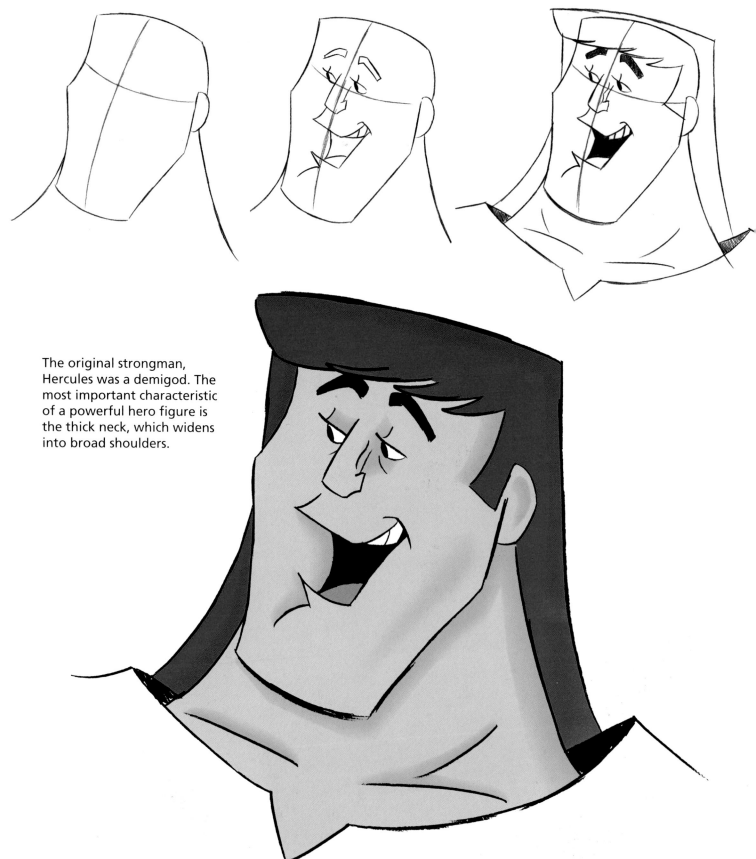

The original strongman, Hercules was a demigod. The most important characteristic of a powerful hero figure is the thick neck, which widens into broad shoulders.

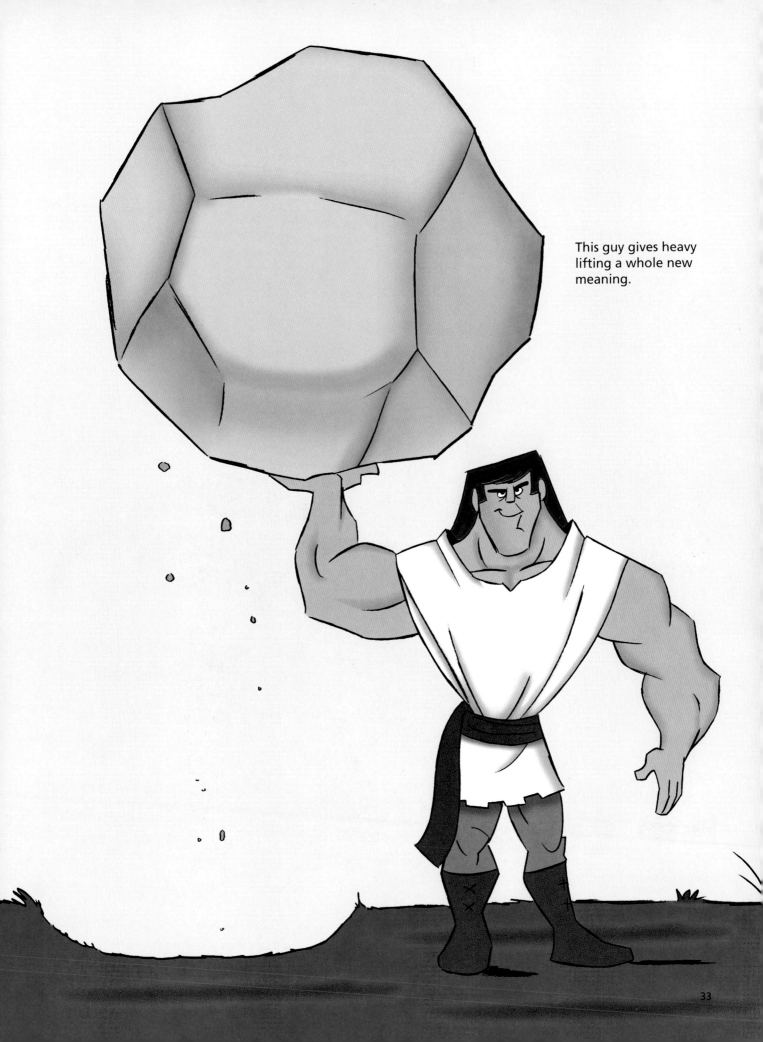

This guy gives heavy lifting a whole new meaning.

Pan

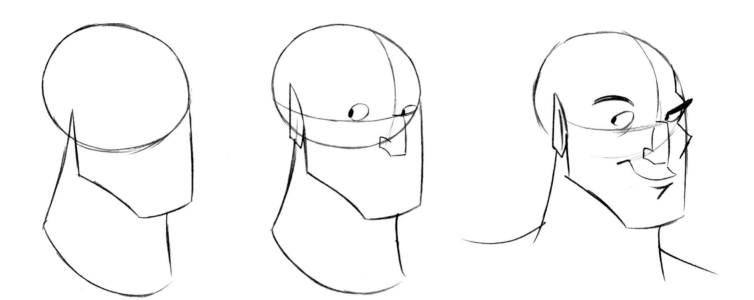

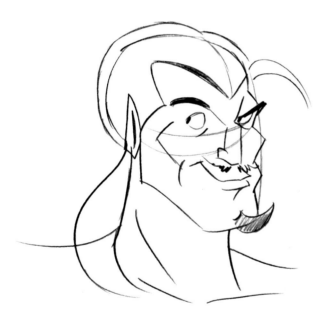

The Greek god of pastures, flocks, and shepherds, Pan is a devilish—but harmless—creature by nature. A popular figure in legend and fantasy, Pan is half man (the upper body) and half goat (the lower body). He should have a slightly wicked look, which could include a goatee, a small mustache, pointed ears, and even horns. Although in my experience, the horns tend to confuse people and make them think of the devil, so I omit them.

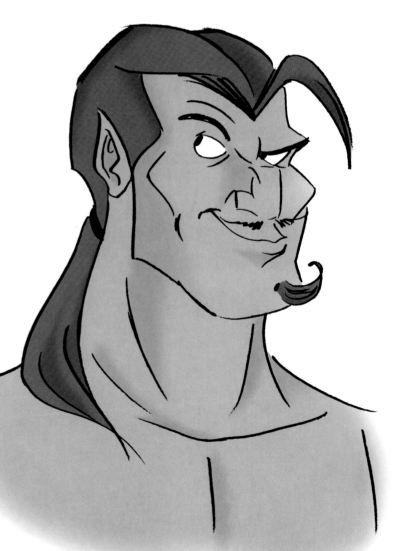

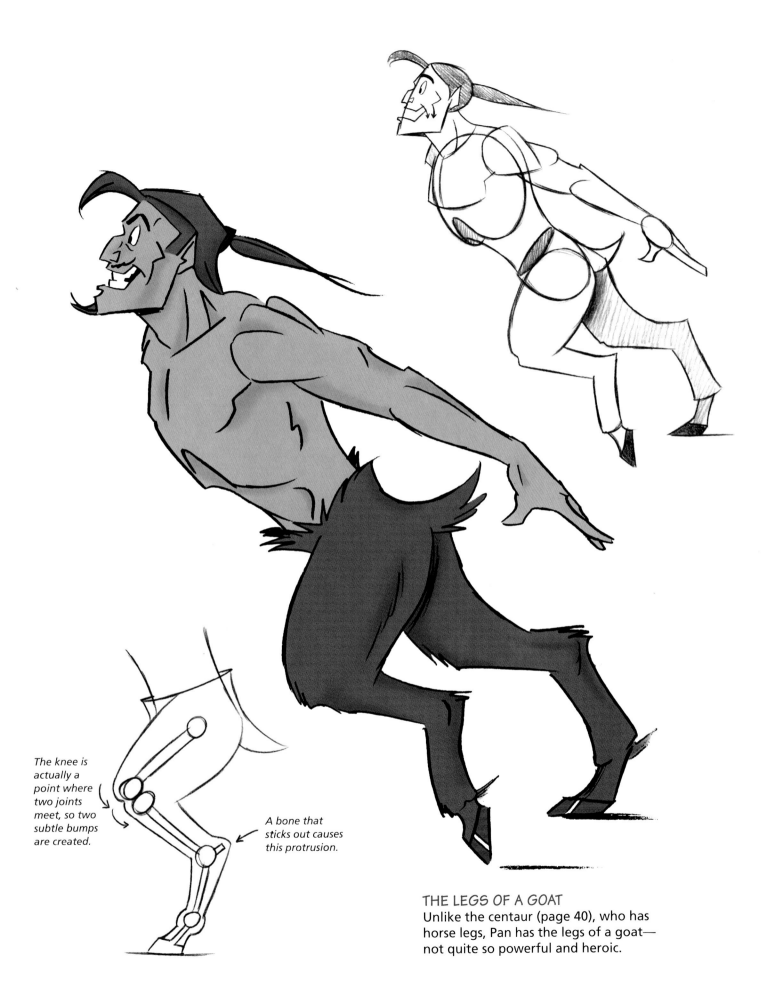

The knee is actually a point where two joints meet, so two subtle bumps are created.

A bone that sticks out causes this protrusion.

THE LEGS OF A GOAT
Unlike the centaur (page 40), who has horse legs, Pan has the legs of a goat—not quite so powerful and heroic.

Pan Courting a Maiden

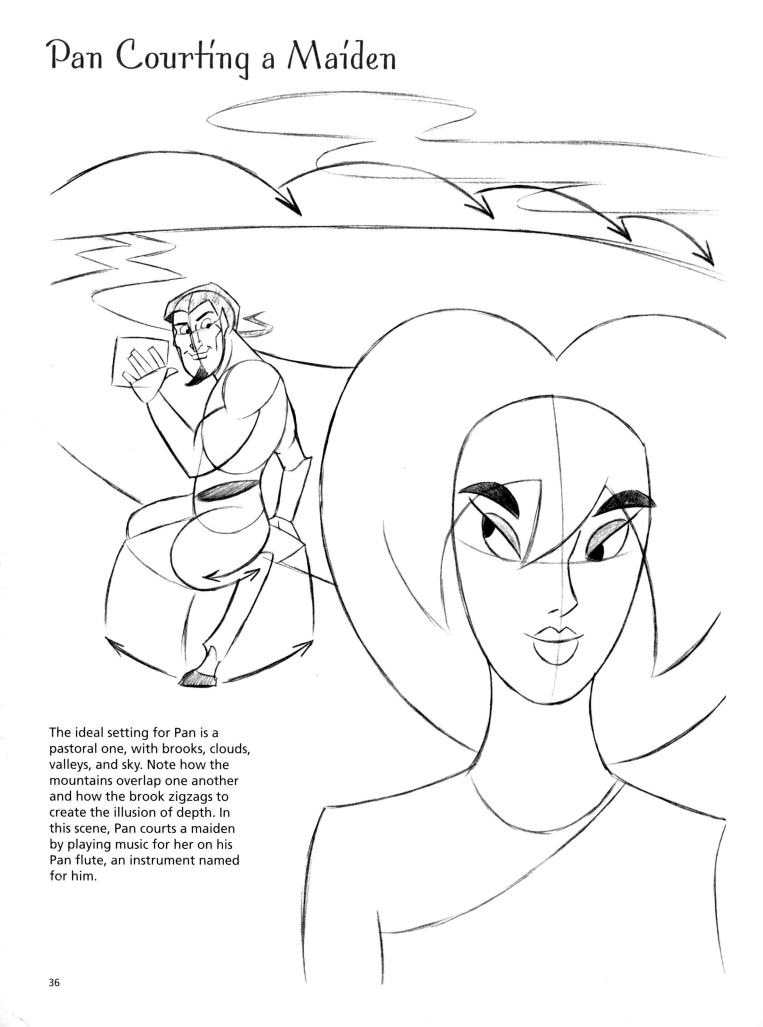

The ideal setting for Pan is a pastoral one, with brooks, clouds, valleys, and sky. Note how the mountains overlap one another and how the brook zigzags to create the illusion of depth. In this scene, Pan courts a maiden by playing music for her on his Pan flute, an instrument named for him.

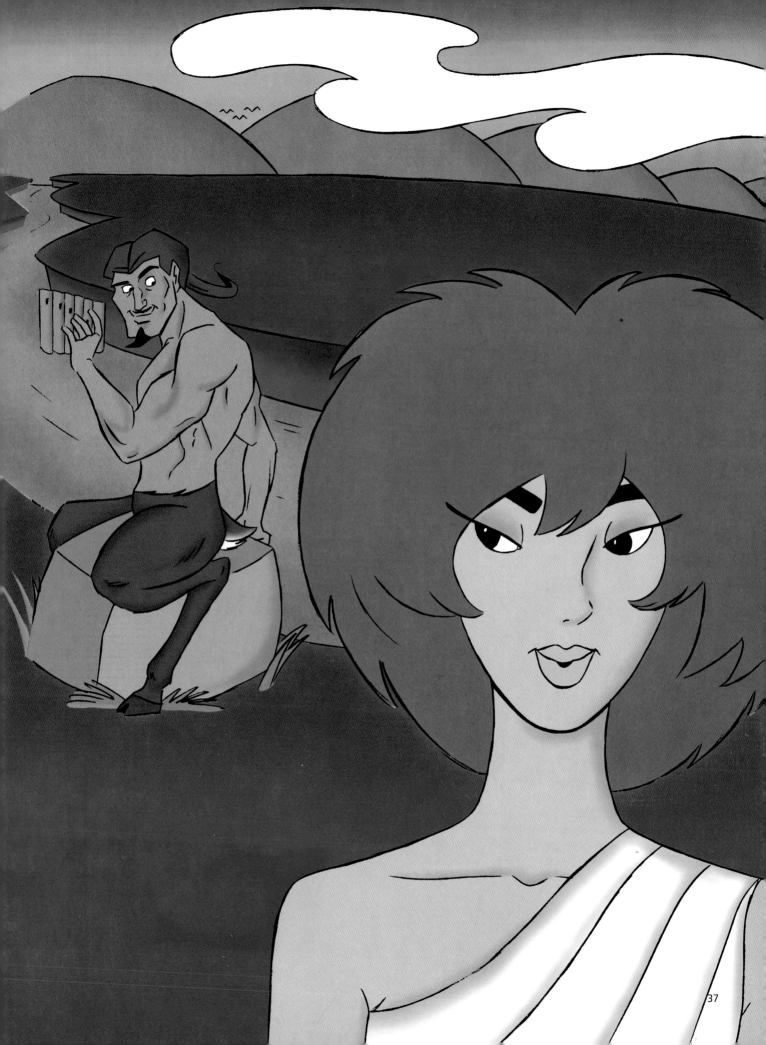

Pegasus

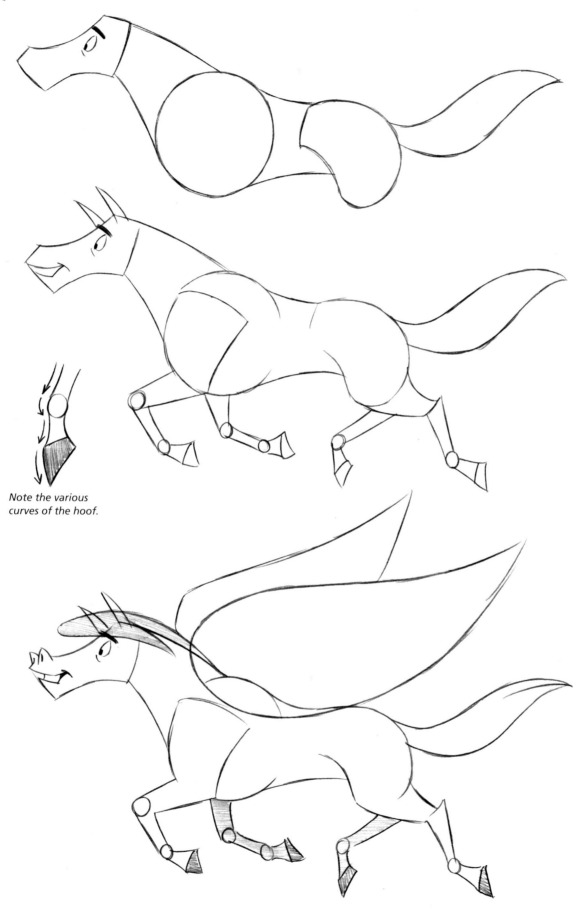

Note the various curves of the hoof.

In legend, there are either unicorns (basically horses with horns) or there is Pegasus, who is a horse with wings. The two characters are never combined—you'll never see a unicorn with wings. When flying, Pegasus should always be posed in mid-gallop. Simply allowing his legs to drag as he flies looks awkward and inactive. Also, his wings must be quite large to keep his body aloft.

The Centaur

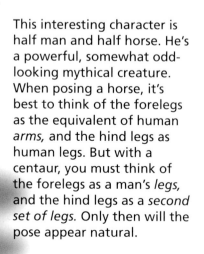

This interesting character is half man and half horse. He's a powerful, somewhat odd-looking mythical creature. When posing a horse, it's best to think of the forelegs as the equivalent of human *arms*, and the hind legs as human legs. But with a centaur, you must think of the forelegs as a man's *legs*, and the hind legs as a *second set of legs*. Only then will the pose appear natural.

The Female Centaur

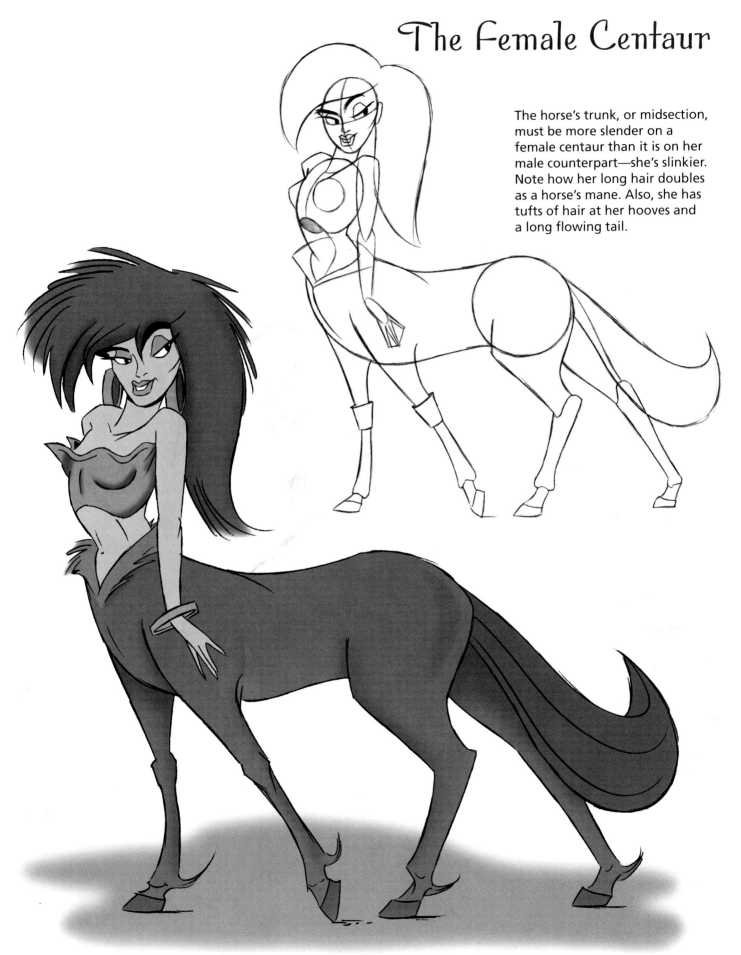

The horse's trunk, or midsection, must be more slender on a female centaur than it is on her male counterpart—she's slinkier. Note how her long hair doubles as a horse's mane. Also, she has tufts of hair at her hooves and a long flowing tail.

Cupid

The Roman god of love—and usually portrayed as a matchmaker in cartoons and animation—this little angel is best depicted hovering in the sky. When he stands, it's usually on a cloud. He's mischievous and sly, and when he misfires his arrows, comedic complications ensue.

Keep Cupid's arms and legs short and chubby, and keep his head large in relation to his body. He should have the proportions of a baby.

Cupid Expressions

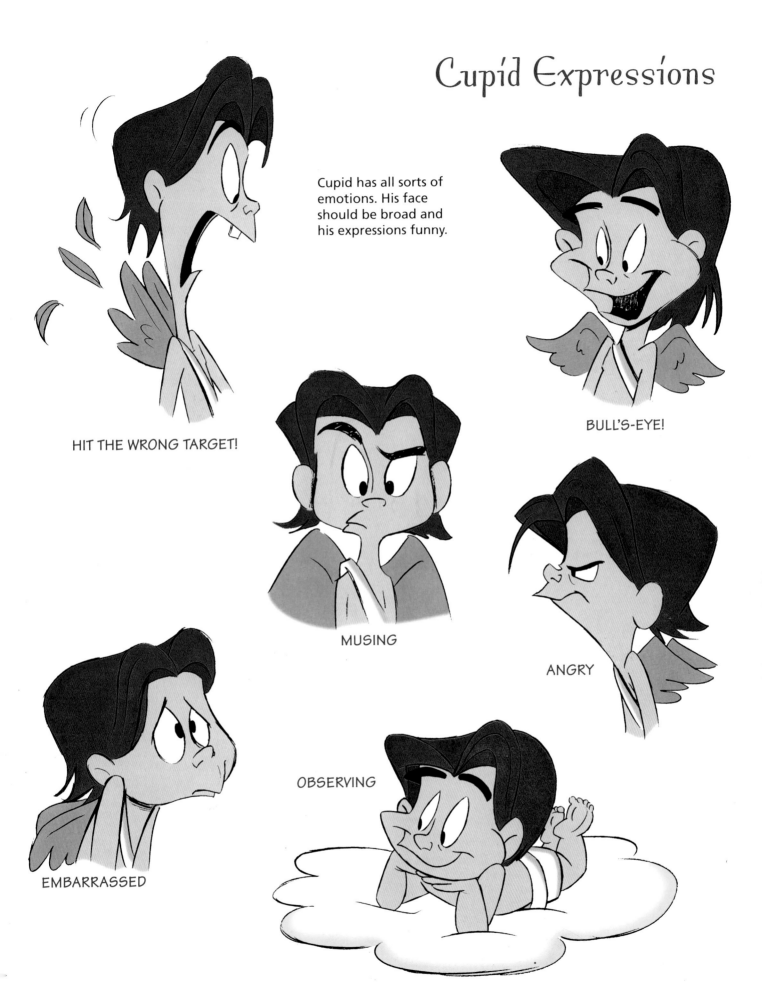

Cupid has all sorts of emotions. His face should be broad and his expressions funny.

HIT THE WRONG TARGET!

BULL'S-EYE!

MUSING

ANGRY

EMBARRASSED

OBSERVING

GENIES, ANGELS, AND FAIRIES

These characters are supernatural creatures whose job it is to help humans. Fairies and angels are the most benevolent of the lot; genies are helpful only because they have been consigned to spend eternity in a lamp.

Male Genie

The male genie must be powerful if he is to create awe-inspiring magic. Give him wide shoulders, and let his body trail off into a wisp of thin smoke that swirls back to his magic lamp. The male genie is often part of a pair; for example, Aladdin and his genie. Here, Aladdin's rib cage tilts up, while his hips tilt down; this gives his pose a dynamic stretch as he rears back in astonishment. The desert is a good backdrop for these two—the sky devoid of clouds, with a large sun beating down mercilessly. A kingdom in the distance and an animal skeleton in the foreground set the scene well.

RIB CAGE TILTS UP

PELVIS TILTS DOWN

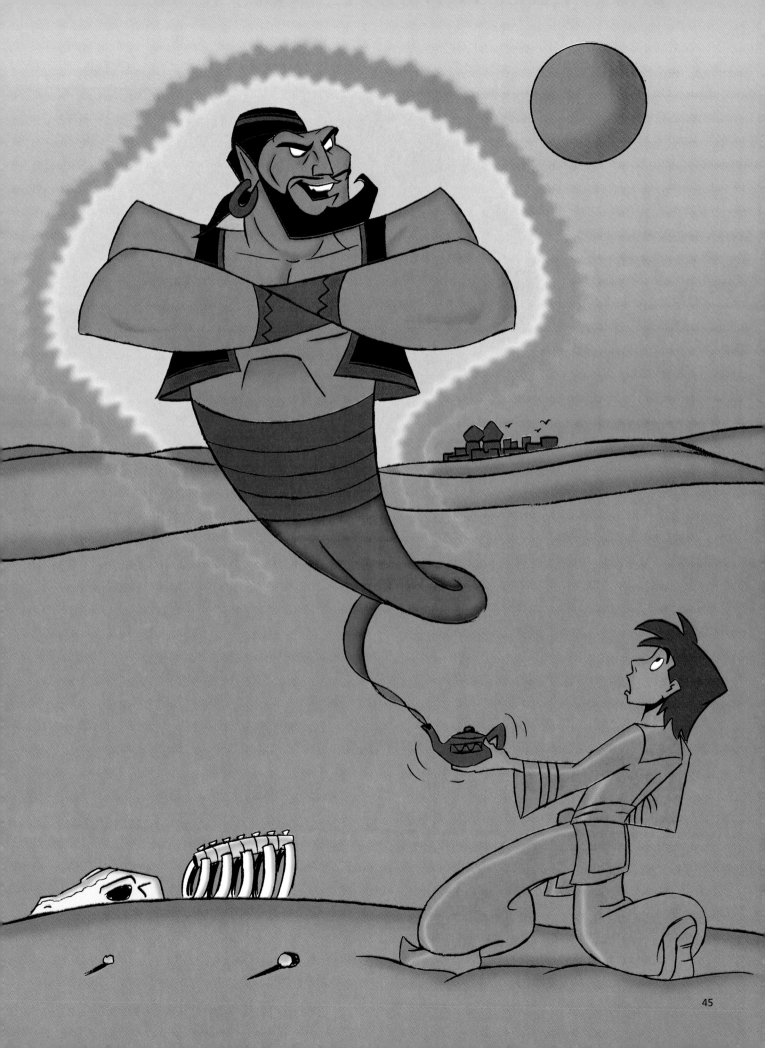

Female Genie

Give this character a high ponytail, huge round earrings, and a mesmerizing stare. She's beautiful, and neither good nor evil. She's magical and mischievous—a powerful force that should not be underestimated.

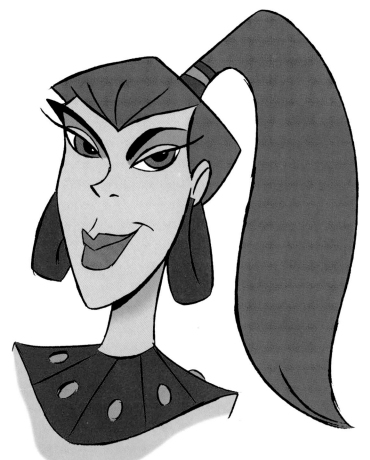

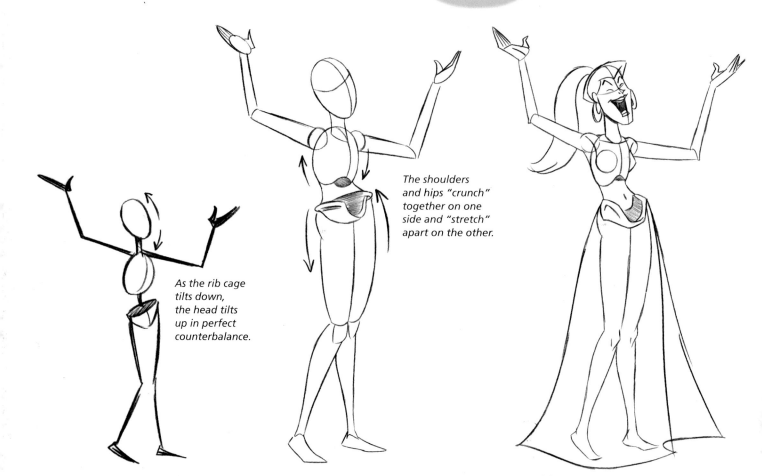

As the rib cage tilts down, the head tilts up in perfect counterbalance.

The shoulders and hips "crunch" together on one side and "stretch" apart on the other.

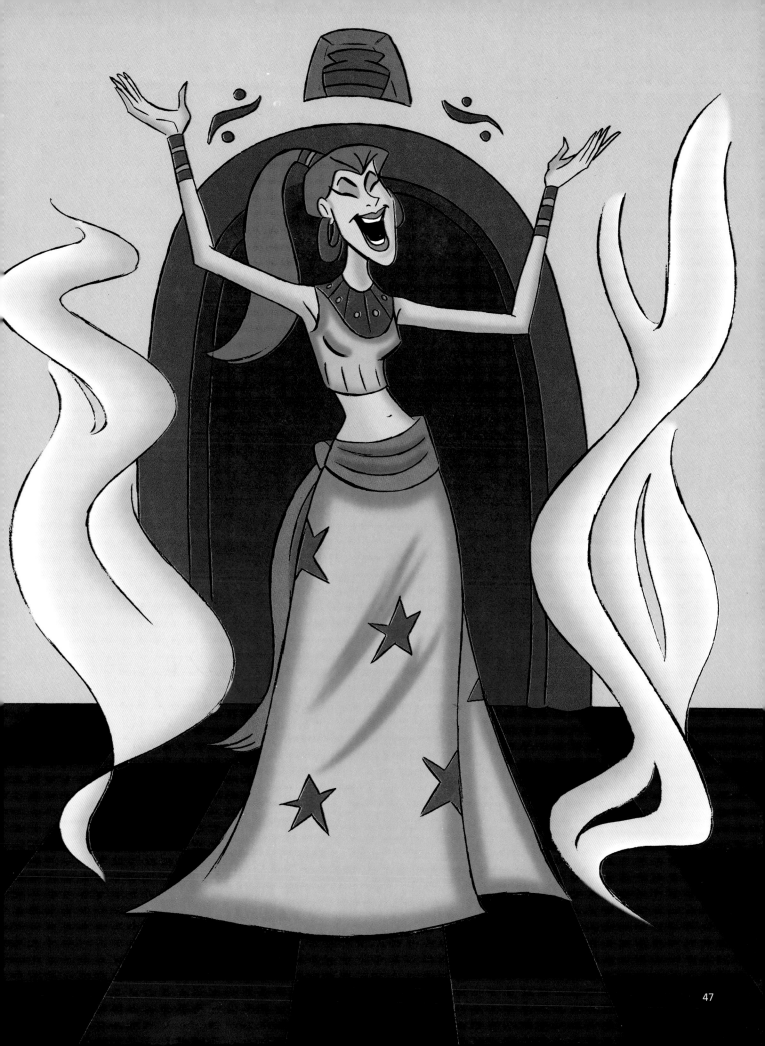

Guardian Angel

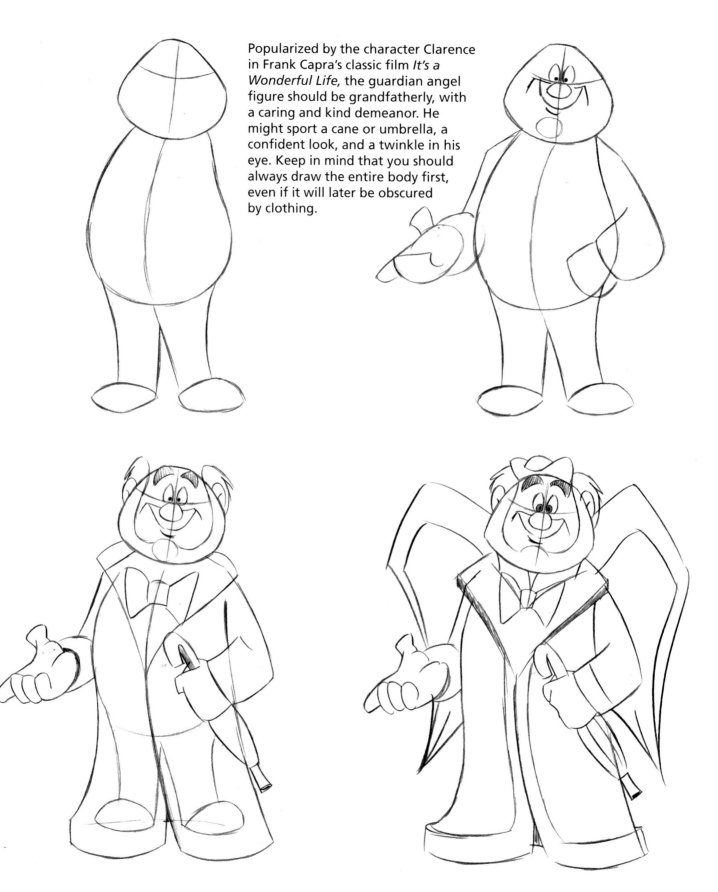

Popularized by the character Clarence in Frank Capra's classic film *It's a Wonderful Life,* the guardian angel figure should be grandfatherly, with a caring and kind demeanor. He might sport a cane or umbrella, a confident look, and a twinkle in his eye. Keep in mind that you should always draw the entire body first, even if it will later be obscured by clothing.

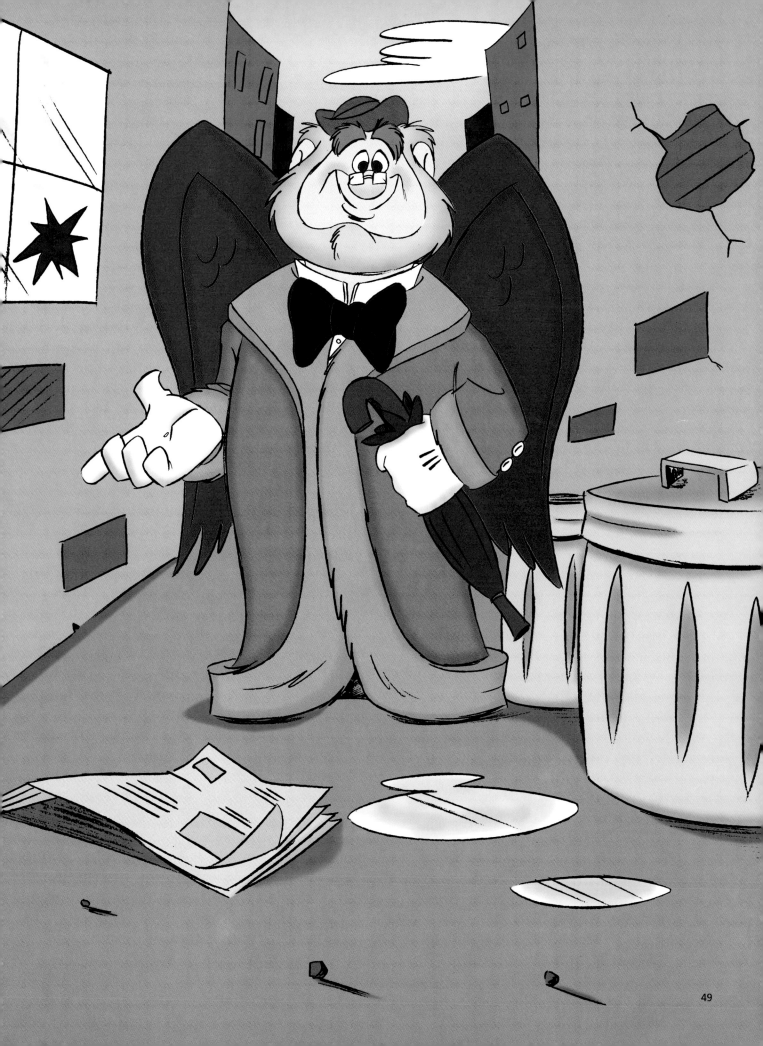

Fairy Godmother

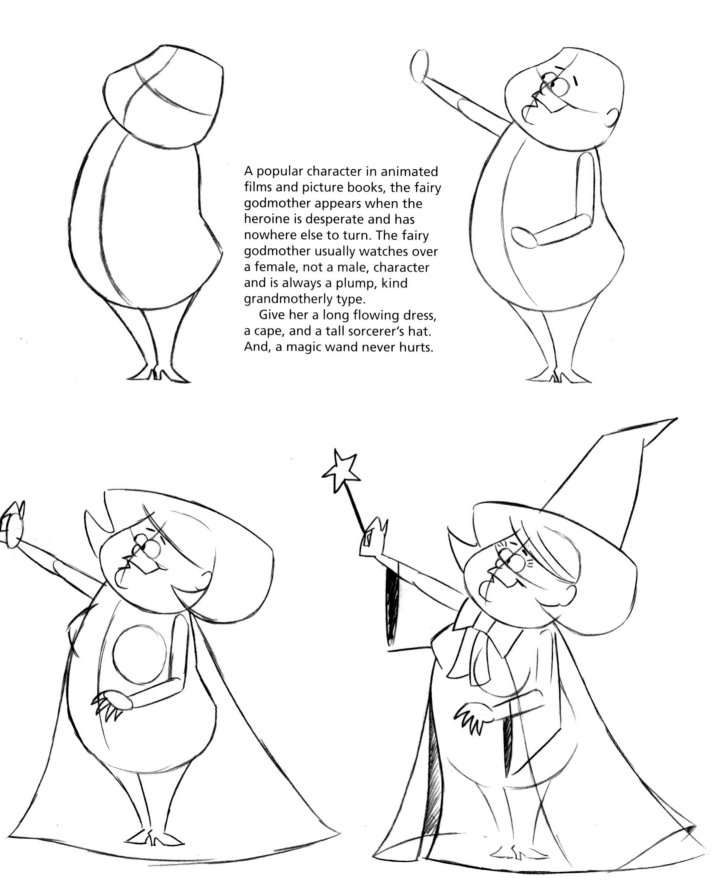

A popular character in animated films and picture books, the fairy godmother appears when the heroine is desperate and has nowhere else to turn. The fairy godmother usually watches over a female, not a male, character and is always a plump, kind grandmotherly type.

Give her a long flowing dress, a cape, and a tall sorcerer's hat. And, a magic wand never hurts.

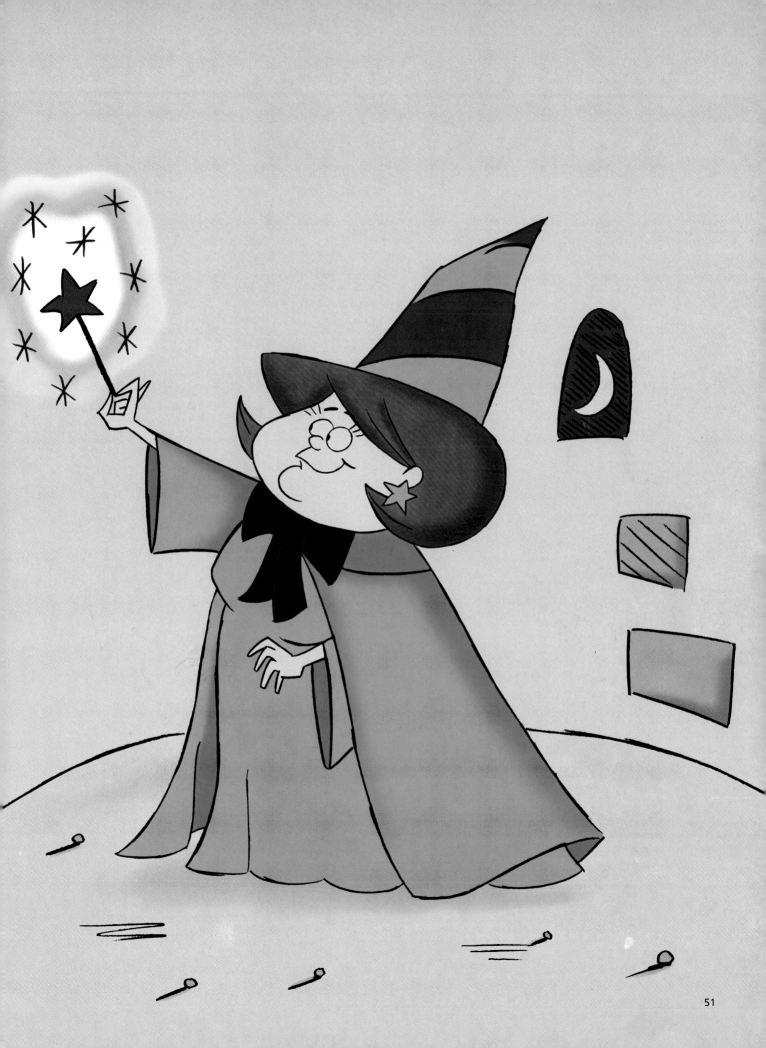

The Tooth Fairy

Quiet and stealthy, the tooth fairy appears in the middle of the night. A scene with the tooth fairy must have an overall feeling of charm and love. Here, the tilt of the tooth fairy's head adds to the appeal of the moment.

CIRCLE OF INTEREST
This is the area where all the elements come together in a drawing and keep the reader's eye moving continuously in a circular path from one important element to the next—from the tooth fairy's head to her hand to the little girl and back to the tooth fairy's head again.

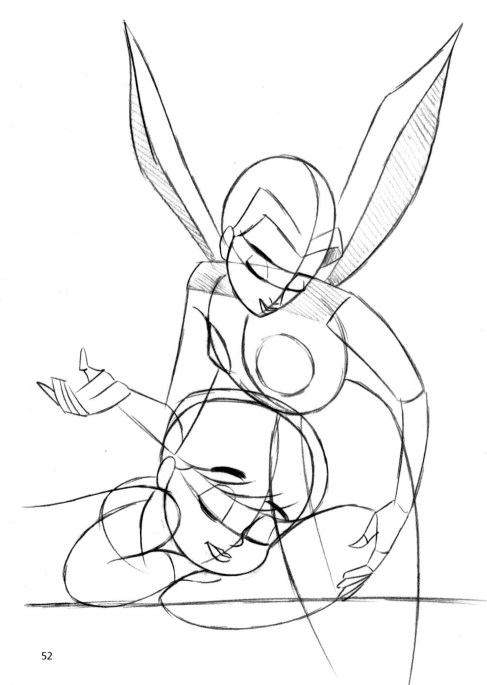

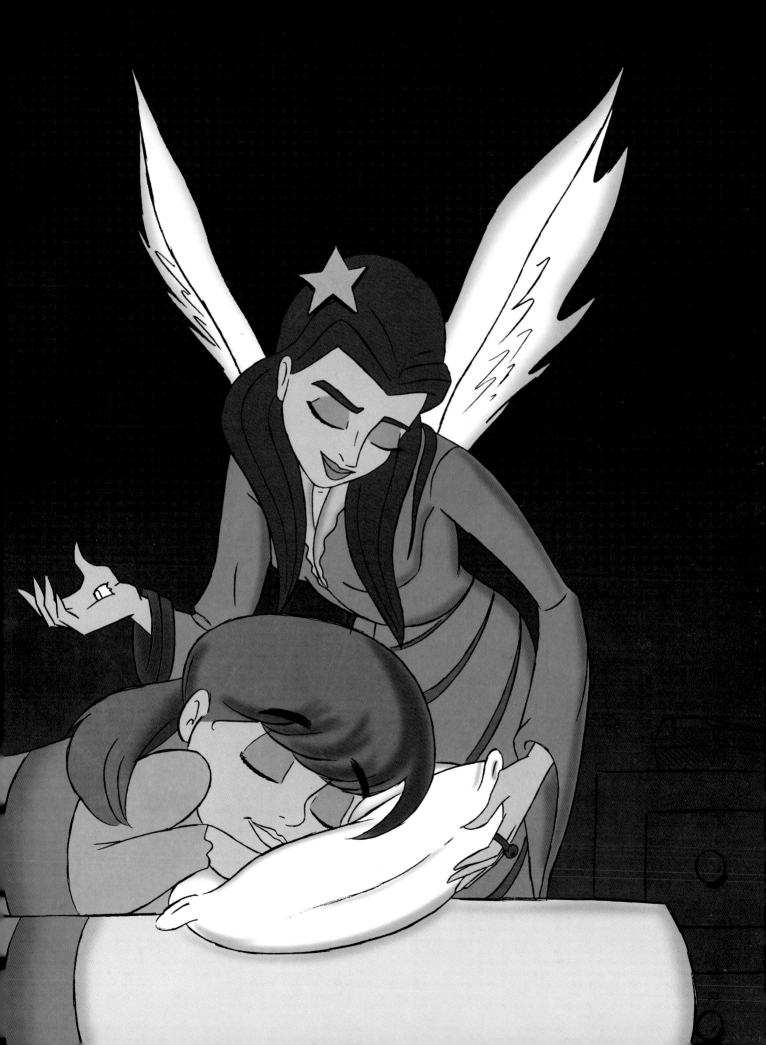

Fairy Princess

The fairy princess is the size of a butterfly and comes from a royal family of fairies. Kind, unassuming, and earnest, she tries to help her people, who may be trapped in a house by a curious dog or stranded on a rock in the middle of a rushing stream.

The only "big person" who the fairy princess trusts is the young girl character. The young girl won't betray the fairy princess to the grown-ups, who would exploit her to curiosity-seekers.

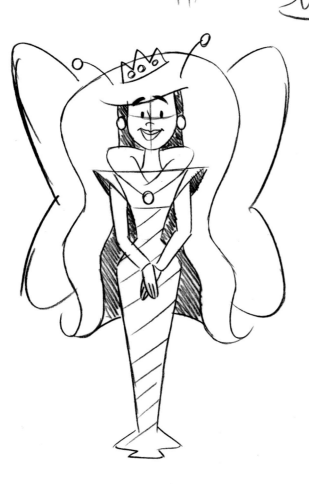

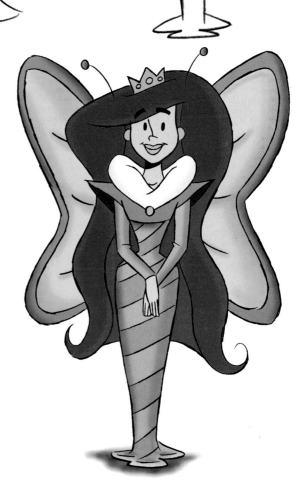

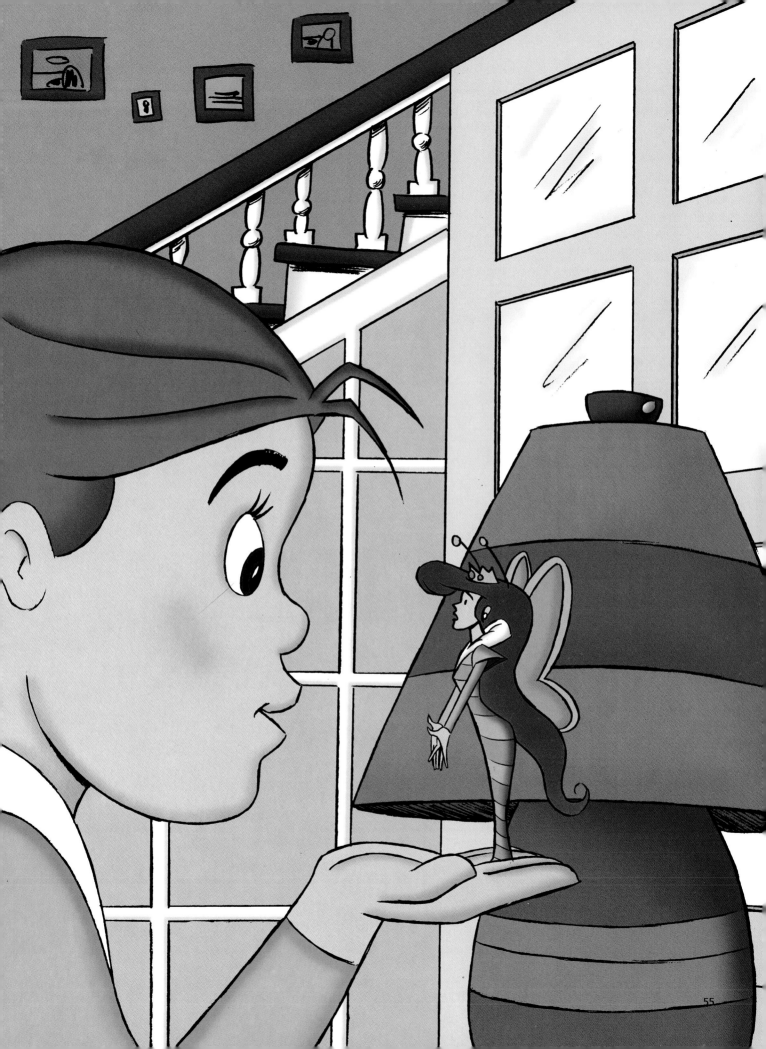

LITTLE FOLK

Little people live in a world unseen by the average person. They are the size of a thimble; to them, a chair leg is a giant redwood. They are also experts at hiding, and they work together as a team to survive in a big world.

Elves

The elf is a tiny, magical creature. The head is large in comparison to the body. The hands and feet should also be large, and the clothing should be loose. Elves often have animal-like features, with slightly pointed noses, long pointed ears, and large mouths (particularly the upper lip area). The eyes should be slender and pointed, as well.

The Elf Habitat

Elves live in a miniature world on the forest floor, among the blades of grass, dandelions, and mushrooms that provide their shade. Tree trunks serve as their homes. A huge harvest for an elf is a single acorn, which can feed an entire elfin family for weeks. Elves live in harmony with nature but are elusive, their presence often suspected but never confirmed.

Gnomes

Cartoon gnomes are similar to elves, but they are more human looking. They are typically older—like little old men—and have rounded noses, not pointy ones as do elves. While elves and gnomes can both have beards, only gnomes are depicted with long mustaches on otherwise clean-shaven faces.

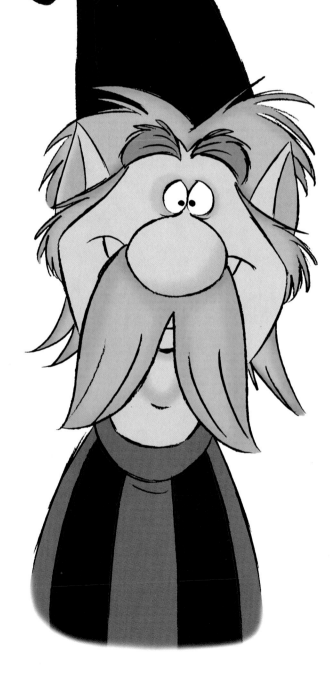

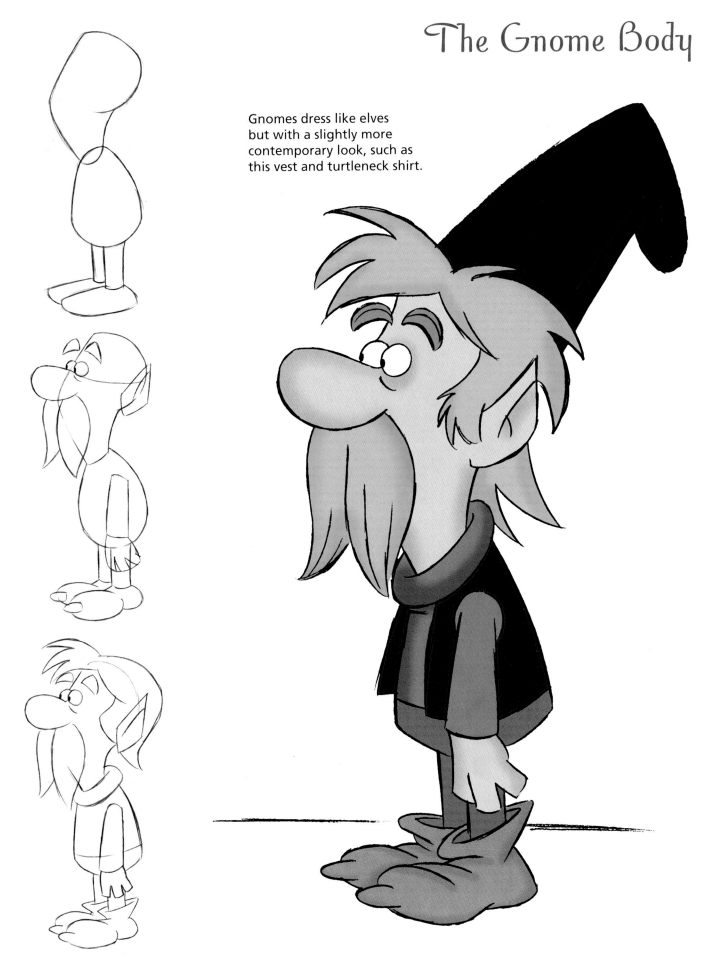

Gnomes dress like elves but with a slightly more contemporary look, such as this vest and turtleneck shirt.

Leprechauns

If you catch a leprechaun, so the legend goes, he will lead you to his pot of gold. However, catching one is all but impossible. Leprechauns are mischievous, clever, and extremely tricky; the one I caught talked me into letting him go. Next time, I'll be more careful.

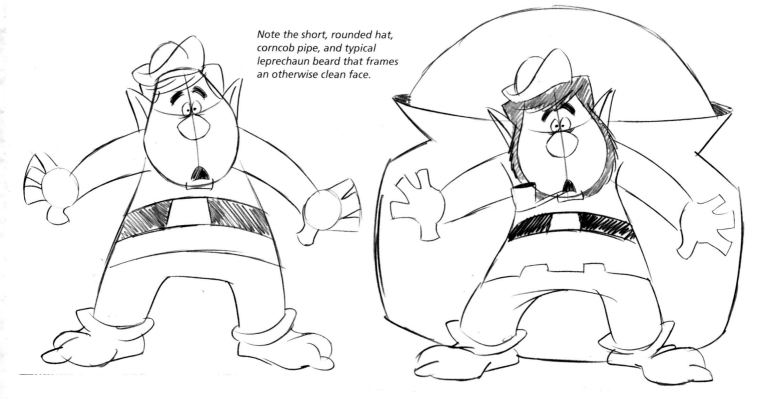

Note the short, rounded hat, corncob pipe, and typical leprechaun beard that frames an otherwise clean face.

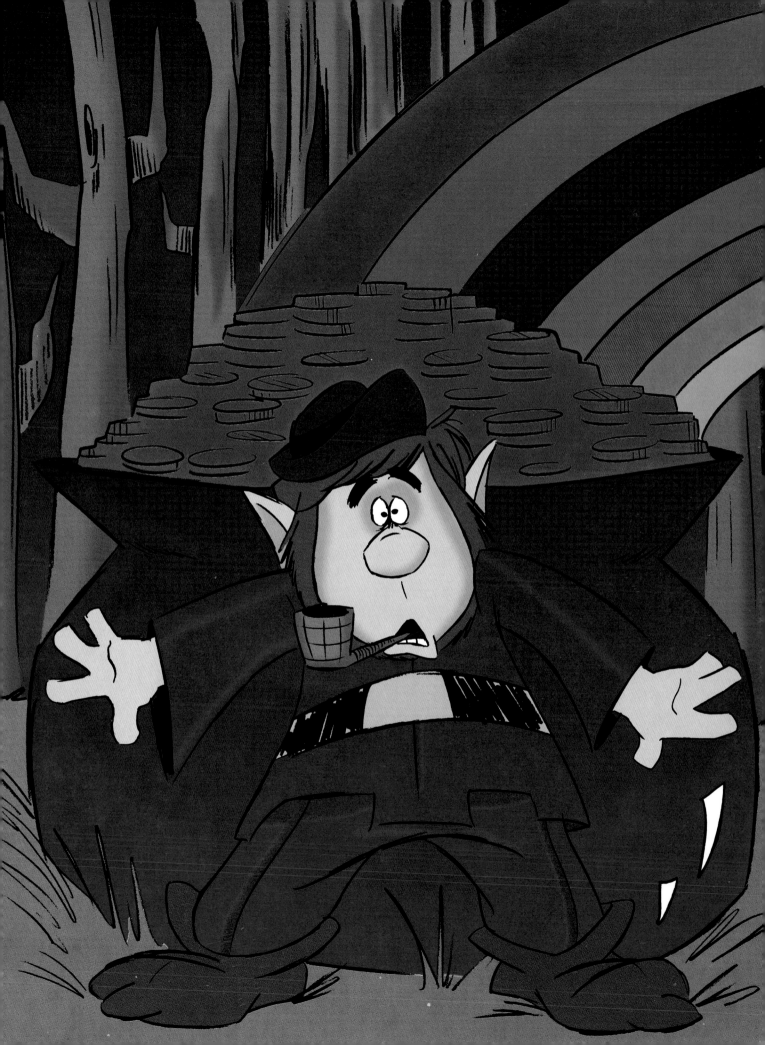

"Little People"

Tiny people in regular-sized settings have been popular characters in fantasy stories ever since *Gulliver's Travels* and have been reinvented countless times in other story situations. To make this type of scene convincing, you must place recognizable, "giant-sized" props in your background settings so that readers can compare the size of the tiny people to their surroundings. These little people are always in a hurry to find a hiding spot—being exposed means risking capture!

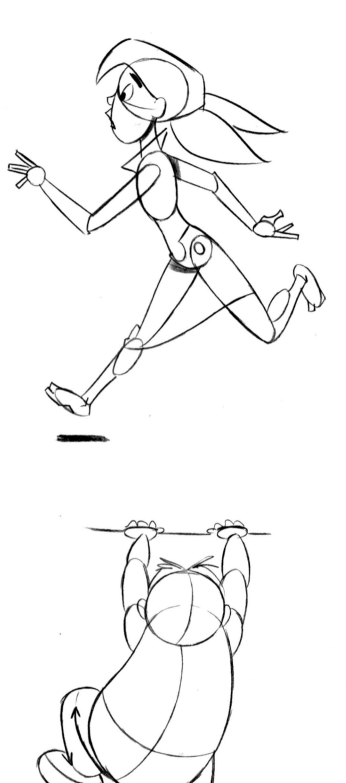

This is what illustrators call a thumbnail sketch— a quick, rough sketch laying out the scene. Once satisfied with the thumbnail, the artist draws the scene in more detail.

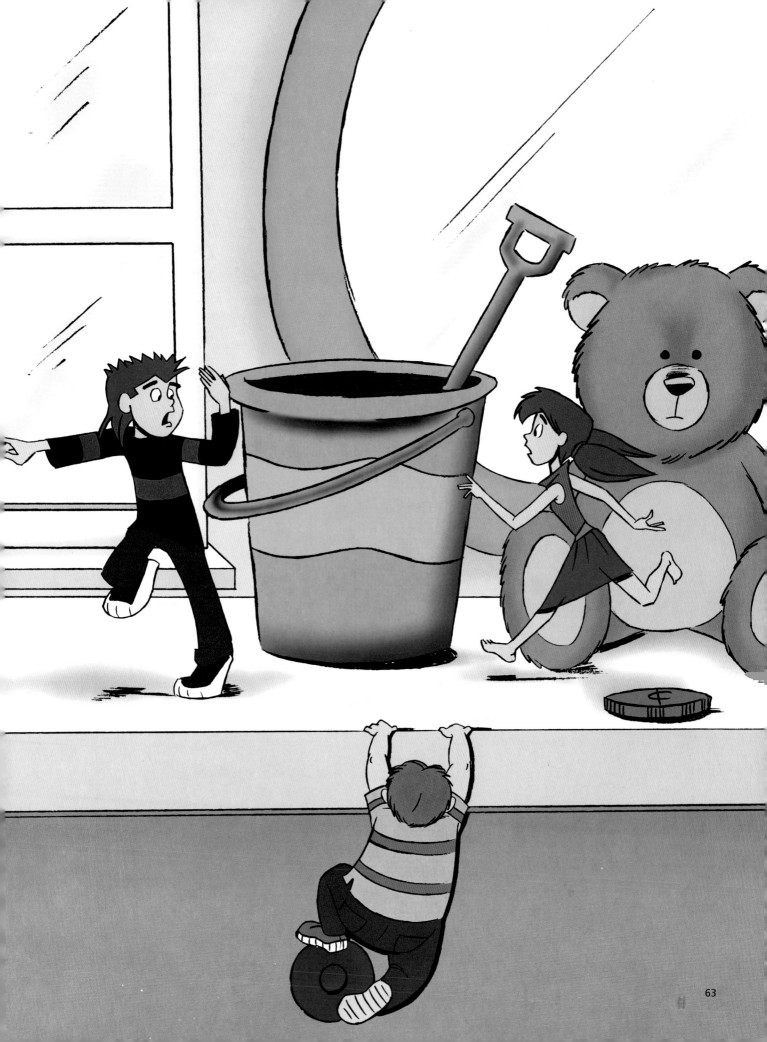

INDEX

Aladdin, 44–45
angel, guardian, 48–49
angry expression, 43

circle of interest, 52
clouds, 25
Cupid, 42–43
cyclops, 28–31

disappointed expression, 21
disdainful expression, 21
dragon, 13

elves, 56–57
embarrassed expression, 43
expressions, 21, 43

facial hair, 22
fairy
 godmother, 50–51
 princess, 54–55
 tooth, 52–53
female
 centaur, 41
 genie, 46–47
 unicorn, 19
 See also fairy

genies, 44–47
giant, 29
gleeful expression, 21
gnomes, 58–59
goat, Pan, 35
guardian angel, 48–49

hair, facial, 22
happy expression, 21
Hercules, 32–33
horns, 15, 34
horse
 centaur, 40–41
 Pegasus, 38–39

leprechauns, 60–61
little folk
 elves, 56–57
 gnomes, 58–59
 leprechauns, 60–61
little people, in regular-sized
 settings, 62–63
Loch Ness monster, 13

merdog, 12
mermaids, 6–11
merman, 12
musing expression, 43
mythological figures, 22–43
 centaur, 40–41
 Cupid, 42–43
 cyclops, 28–31

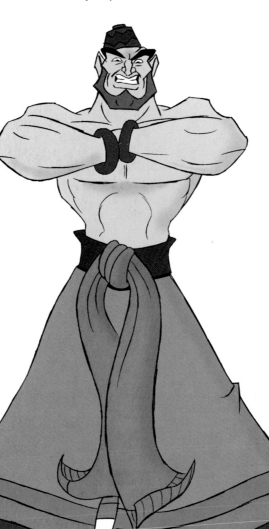

Hercules, 32–33
Neptune, 26–27
Pan, 34–37
Pegasus, 38–39
Zeus, 22–25

Neptune, 26–27

observing expression, 43

Pan, 34–37
Pegasus, 38–39
perspective, 8, 31
pleased expression, 21

sea creatures, 6–13
 merdog, 12
 mermaids, 6–11
 merman, 12
 sea serpent, 13
supernatural creatures
 fairies, 50–55
 genies, 44–47
 guardian angel, 48–49
surprised expression, 21

tooth fairy, 52–53

uncertain expression, 21
underwater pose, 6, 8
unicorns, 14–21
 body, 18–20
 female, 19
 front view, 16
 head, 14
 horn placement, 15
 3/4 view, 17
 young, 20–21

young character, 20–21

Zeus, 22–25